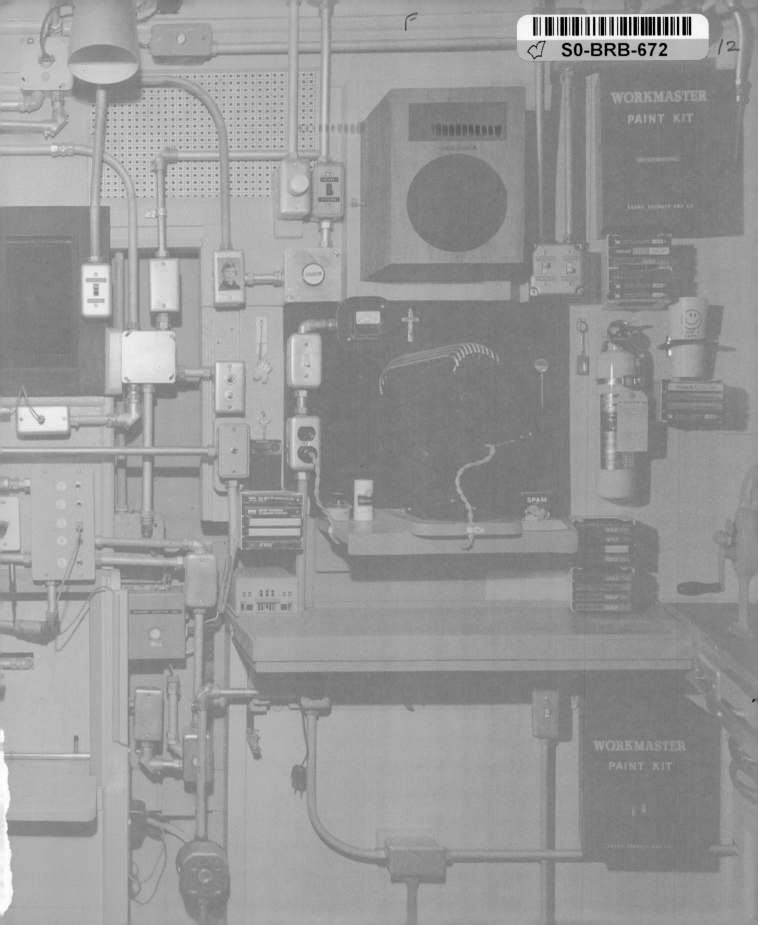

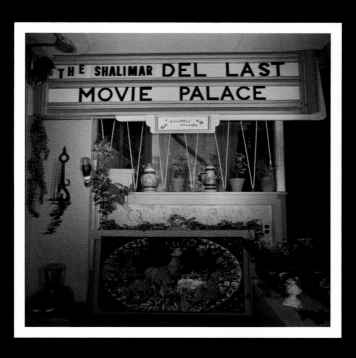

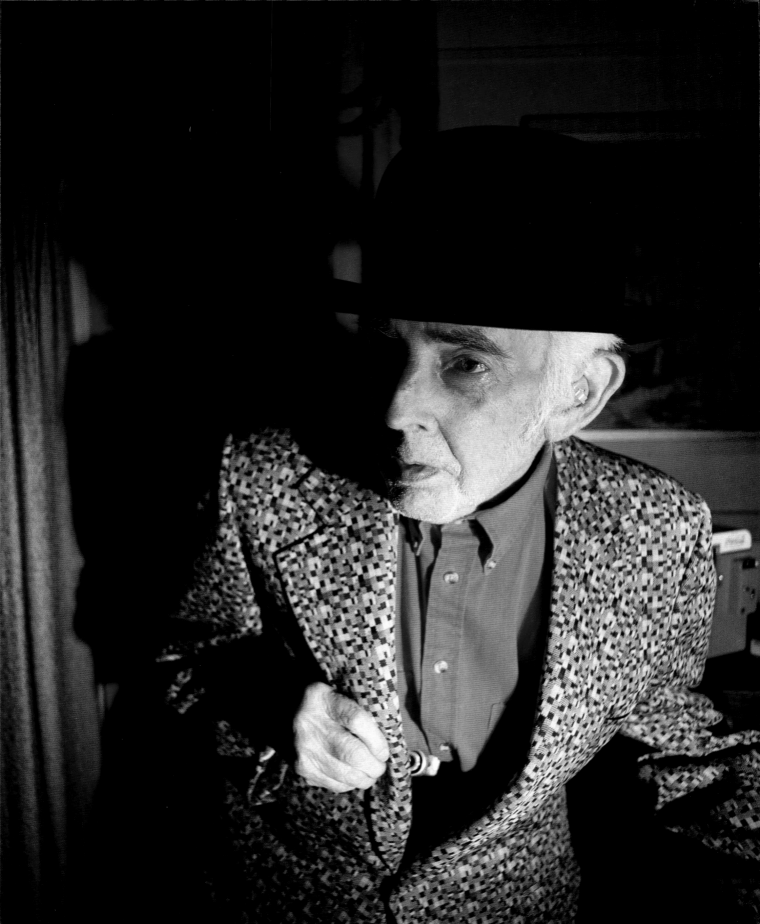

THE PROJECTIONIST

KENDALL MESSICK

Princeton Architectural Press, New York

For Peggy –
All my love,

[signature]

CONTENTS

ACKNOWLEDGMENTS

The Projectionist is dedicated to Gordon and Dorothy Brinckle who so generously allowed me into their lives and entrusted me with the privilege of telling Gordon's story and preserving his creative legacy. My heartfelt appreciation goes to Mark Sloan and Brooke Davis Anderson for their insightful contributions to the book, and I am especially indebted to Sara Bader, Nicola Bednarek, Jan Haux, Kevin Lippert, and the entire staff at Princeton Architectural Press for their passionate belief in Gordon's story. I would like to specifically thank the following individuals and organizations who willingly gave their love, time, support, encouragement, and talents and helped make *The Projectionist* a reality: Suzanne and Everett Forsman, Sam and Peggy Bowser, Lida Burris Gibson, Anderson Hord, Victor Faccinto, Tree of Life, Brenda Hunt, Luciana Pampalone, James Baldi, Athar Qureshi, Robert and Carolyn Bennett, Janet and David Shepherd, Rita Leistner, Sharon Mills, Abe Abdulla, Susan Harbage Page, Robert Cotnoir, Ben Diep, Derrick Arjune, Sam Merians, Joe Rodriguez, Chuck Bogana, Color One, Patricia Katchur, Justin King, LTI, George Hemphill and Lenore Winters, Mary Early, Jessica Naresh, Natalie Zelt, Michelle Anne Delaney, Marty Edwards, Allison Perkins and Cliff Dossel, Susan Crawley, Julian Cox, Linda Dubler, Kate Baillon van Rensburg, Tanya Heinrich, Tom Patterson, Andrea Douglas, John A. Bennette, Audra Thomas, Kendall McCabe, Louis "Chuck" Mandes, Dustin Kersnowski, Scott and Grace Lawrence, Ellen Combs, Pam Barrett, Scott Davis, Albert Maysles, Natalie Matutschovsky, Michael Trincia, On Target Fabricating/Estimating, Jay Pastore, Holly Lee and Lee Ka-Sing, Helen and Tim Atkinson, Lisa Crumb, Patricia Chenenko, Jill Hartz, Cara White, Anne Lawrence Guyon, Peggy Brown, Thomas and Angela Bowser, Mayan Islam, Rebekah Jacob, Joyce Beck, Sheng Chi-Chen, Seven Arts Framing, and Leslie Umberger. Finally, I would also like to dedicate this book to the memory of Sandra Brinckle Bowser.

FOREWORD

Kendall Messick is a photographer of uncommon perception and perspicacity. He has spent much of his artistic life documenting elderly individuals of extraordinary character in a style that reveals his subjects in translucent layers. His focus on aging artists lends his work a palpable sense of urgency. As the old African proverb goes, "When an old man dies, a library burns to the ground." It is fortuitous that Messick's world collided with that of Gordon Brinckle. It is rare indeed to encounter such a singular creator with his creation—in this case, a movie palace in the place of a library—still intact in such a hidden location. Messick knew this had to be preserved, and he did so in his own unique fashion.

Messick is not limited by the still image or the distinctions between black-and-white and color photography. When necessary, he employs video, installation, or combined media, as with his extended portrait of Brinckle and his dream made manifest—the Shalimar Theatre. What Messick has created is a multidimensional homage to a fever dream. Through the modalities of photography, Brinckle's drawings and ephemera, a video documentary, this book, and the reconstructed Shalimar, Messick has provided us with a powerful testament to one man's lifelong passion—his "mistress in the basement."

America is filled with tinkerers, dreamers, and visionaries—it always has been. Most, though, have gone unnoticed, or unchronicled. Brinckle's dream for the Shalimar was pure, yet he did not care to screen movies in it; it was enough to build it—to know it was there, if needed.

Messick's black-and-white photographs of Brinckle's everyday world in the upstairs of his house are heartbreaking in their ordinariness. The detritus of his working-class life subsumes Brinckle's geriatric body. Then Messick takes us through the portal to the Shalimar, and we enter the Technicolor realm of Orpheus's underworld—Brinckle's dreamworld—where anything can happen. A stage, a screen, a curtain—anticipation is all in this realm. It is pure poetry.

Messick is entitled to the mantle of Keeper of Flames. He has demonstrated a remarkable capacity for capturing the longing of the human spirit—to live on, to endure, to mean something. He follows Brinckle through his last days, even through his burial, and makes sure he lives on in his work. I am struck by the curious Möbius effect that occurs when I look at the photograph of Brinckle in his wheelchair, viewing the video documentary about his making of the Shalimar—on the screen of the reconstructed theater, in a warehouse, before its national tour (see page 97). This image creates a conceptual whiplash, looping back on itself as it extends into the book in your hands.

Mark Sloan
Director and senior curator
Halsey Institute of Contemporary Art

PREFACE

You never know what people keep in their basements. The home of the late Gordon Brinckle (1915–2007) in Middletown, Delaware, was a stellar example of just how unexpected a basement's contents can be. Who would believe that a house whose exterior reflects the familiar, cookie-cutter architecture of the 1950s once contained a fully operational 1920s-style movie palace?

In 1969, when I was four years old, my family moved into the house across the street from the Brinckle family— Gordon, Dorothy (Dot), and their daughter, Sandy. Sandy used to babysit my brother and me, and it was through her that I discovered the Shalimar, her father's movie palace in the basement. Although I saw it only once as a boy, a distinct impression of something wonderful remained with me through the years, which would eventually lead to my fortuitous return visit twenty-five years later and the subsequent realization of *The Projectionist*.

Back in the 1960s, Middletown was a one-stoplight town surrounded by farmland; fast food restaurants, chain stores, and cultural opportunities were at least a half hour drive away. For a young boy, the only real excitement the small town had to offer was the Everett Theatre and its weekend programming of the newest movie releases. Gordon was the projectionist of this single-screen theater that had been operating since 1922.

The Brinckles were not particularly social people. Gordon's wife, Dot, was a bit more outgoing, but Gordon had always been a loner. Though I remember seeing him walking down the aisle of the Everett with his flashlight as he headed up the stairs to the projection booth on Friday and Saturday nights, my boyhood impressions of him are vague.

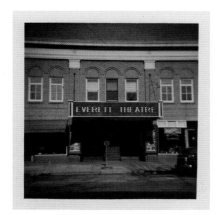

The Everett Theatre, Middletown, Delaware, ca. 1948

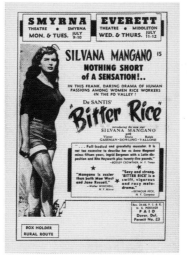

Everett Theatre advertisement

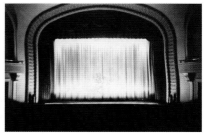

The Everett Theatre, interior, ca. 1948

Everett Theatre movie ticket, ca. 1948

9

On the rare occasions that I ran into the Brinckles, Dot typically took the lead in conversations while Gordon silently looked on. I later came to learn that during most of his adult life, Gordon spent his days in the basement building the Shalimar, his own miniature version of a movie palace, while at night he was behind the projectors at the Everett, showing films to eager audiences. His busy work schedule, coupled with Gordon's reticence, meant that only a precious few knew of the existence of his fantastic creation.

In December of 2001, I was visiting my mother, who still lives in my childhood home in Middletown, when she got the news that Sandy had died after a long battle with cancer. I accompanied my mother across the street for a visit to the grieving parents and couldn't help but wonder whether the theater was still there after so many years. I later asked Gordon about it and he replied, "She's decorated for Christmas. Would you like to see her?" And with that, he led me down the basement stairs like the usher that he had been years before.

I was unprepared for the experience of seeing the Shalimar that day. My childhood recollection consisted of a vague impression of a stage, theater seats, and a box office. The reality of Gordon's "theatre of renown," as he lovingly called it, however, was beyond anything I could remember or even imagine. Everywhere I looked, there were intricate details in the design and decoration that spoke to Gordon's passion and obsession. In the tradition of the movie palaces of the past, he had decorated the auditorium for Christmas. The added layer of ornament took the opulent 1920s style to new heights, leaving me with questions about the quiet man that was behind such a creation. Shortly thereafter, I asked Gordon whether he would allow me to document his life and his theater, so that his story could be shared with others. He was immediately enthusiastic, and I began to work with him in late 2001.

From the birth of the motion picture in 1895 to the middle of the twentieth century, theaters that housed the projected image underwent a significant evolution. In the early days, movies were shown in opera houses and theaters originally intended for live performances. Then nickelodeons, small storefront theaters that featured movies all day

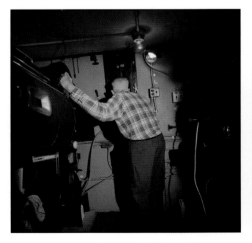

Gordon in the Everett projection booth, 2002
(photo by Kendall Messick)

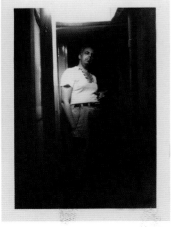

Gordon in the projection booth, 1958

long, appeared, bringing the moving image to the masses. Neighborhood theaters popped up in small towns all across America, and grand, ornate movie palaces were built in big cities. As the popularity of feature films increased, reaching its height in the 1940s, so did the size and complexity of detail that went into the design and building of movie theaters. Studio head Marcus Loew once commented, "We sell tickets to theatres, not movies."

Gordon Brinckle was born and raised in Philadelphia, Pennsylvania, when opulent movie palaces were just beginning to enter their heyday. A sickly child that doctors predicted might not make it to adulthood, he became enamored with movie projectors and theaters as a boy. Gordon's great-grandfather had owned and operated the Fulton Opera House in Lancaster, Pennsylvania, for more than thirty years, which may have led to his great-grandson's early interest in theaters. What began as a childhood diversion came to define his entire life, as he worked in almost every imaginable occupation associated with the presentation of film and eventually fulfilled his dream of owning an actual movie palace in a most unconventional way.

As a teenager in West Philadelphia, Gordon demonstrated early artistic talent while attending vocational school. He enjoyed creating detailed drawings, which were not mere renderings from everyday life, but original designs and depictions of imaginary objects and people. After completing vocational school, Gordon became an apprentice to a prominent Philadelphia theater decorator. This apprenticeship built on his interest in theaters and taught him the practical skills of upholstery and drapery work and general construction. Most notably, in this new role, his interests in art and theaters came together as he learned how to draw to scale. Soon theater designs and architecture came to dominate Gordon's creative output, which would ultimately span more than sixty years. His intricately detailed drawings range from theater blueprints, cross sections, and floor plans to interior and exterior designs drawn to scale. He often made complete sets of plans for a specific imaginary theater. Not only are these compelling for their aesthetic appeal, but they show that in addition to his attention to design and decorative elements, Gordon was conscious of the

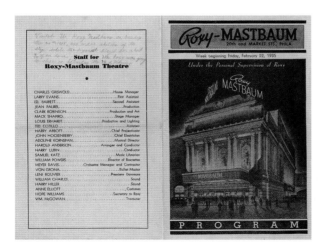

Program of the Roxy-Mastbaum Theatre, one of the grand movie palaces of the 1930s

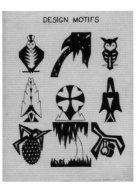

Design motifs by Gordon Brinckle,
ca. 1932

Gordon Brinckle, ca. 1920

functional requirements of a theater. For instance, men's and women's restrooms, concession stands, projection rooms, and offices were typically included in each set of plans. In the 1930s, while still in vocational school, he learned how to carve linoleum blocks for custom-printed stationery. This later led Gordon to create block print designs in the art deco style for theater tickets, programs, and stationery. Interestingly, he primarily chose to design and draw modest theaters with a high degree of originality rather than the grand movie palaces that so inspired him. His aspiration was to create small theaters that people would be comfortable in, which borrowed many of the distinctive design details from the early movie palaces.

During his early adult years, Gordon's imagination, tenacity, and newly learned skills culminated in the construction of his first theater in the basement of his parents' home in 1936. This small but intricately adorned movie palace, which he named the Alvin Casino, was authentic to the last detail, including a working projection booth, a curtained screen with art deco proscenium, as well as a marquee and ticket office just outside the theater entrance. Despite Gordon's lifelong tradition of designing theater spaces on paper, he never created scale drawings that had a direct relationship to the theaters he constructed. Although he used the names of his theaters, such as the Alvin Casino, on many of the drawings, he never constructed them from plans. Nonetheless, the Alvin Casino turned out so distinctive that local Philadelphia newspapers sent journalists to profile the theater in 1941.

Gordon's apprenticeship with the theater decorating company lasted for three years and was followed by stints working in various Philadelphia movie theaters as an usher and ticket collector. He harbored the dream of becoming a projectionist, but at the time the union for projectionists was strong, and it was difficult to break into the profession without connections. As a result, Gordon took any available position that placed him within the theaters that he so loved.

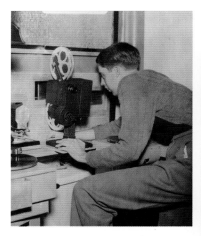

Gordon at the projector, 1941

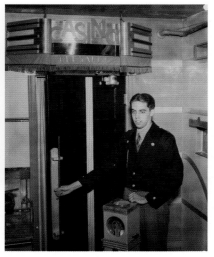

Gordon at the ticket chopper of the Alvin Casino Theatre, 1941

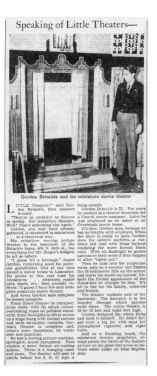

"Speaking of Little Theaters,"
article about the Alvin Casino, 1941

In 1942, at the age of twenty-seven, Gordon was drafted into the U.S. Army during World War II. Amazingly, this event finally allowed him to realize his dream. On his Army admissions paperwork, Gordon listed his profession as projectionist, despite his limited professional experience projecting films, and he was soon called on to screen military training films in American forts extending from Virginia to Georgia to Texas. An overseas deployment to India and China in 1945 followed, where Gordon had the singular experience of constructing and operating an outdoor movie theater (which he called the Fox) on top of a mountain, erected to show the latest Hollywood movies to U.S. troops in an effort to boost morale. Gordon obtained a piece of sailcloth from the U.S. Navy to fashion the screen, replete with ersatz drapes, and even built a freestanding mini-marquee inscribed with a dash of his delightfully wry humor: "air conditioned." According to Gordon, he derived pleasure not from watching the movies but from hearing the responses of the audience and knowing that he was "making it all possible."

Returning from the war, Gordon was hired by the owners of the Everett Theatre in Middletown, Delaware. Designed by the noted Philadelphia theater architects Hoffman and Henon, the Everett was modest in size with a seating capacity of five hundred and boasted proscenium draperies, upholstery, and wall coverings that typified theaters of the early twentieth century. Working his way up from doorman to manager, then to projectionist, his years at the Everett made a lasting impact on Gordon's sense of identity, from the "snazzy" jackets that he would wear to take tickets, to his long-held moniker, "the Movie Man," to being told by staff that he moved "like a dancer" as he simultaneously operated the twin carbon arc lamp projectors.

He held this post for thirty-three years until competition from multiplexes forced the single-screen theater to close. Gordon's dismay at what this portended was palpable in interviews I had with him. "When you compare a movie theater today, it's such a cheap looking affair. It just doesn't hold up."

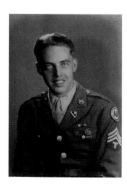

Gordon Brinckle, army photograph, ca. 1945

The Fox Theatre, Kunming, China, ca. 1946

G.I. Movie Weekly

G.I. Movies cover

Throughout his life, Gordon dreamed of owning an actual movie palace, but on a projectionist's salary the possibility of accomplishing this goal seemed remote at best. So in 1959 he began building his dream in the basement of his Delaware home. At this point he had been living in Middletown for twelve years with his wife, Dot, whom he had met during the war, and their young daughter, Sandy. The Shalimar is a larger, grander version of the Alvin Casino. Gordon inventively combined and adapted various styles that were popular during different periods of the twentieth century to craft an environment that was completely original. Gordon's theater boasts a marquee that distinctly recalls the 1960s; an auditorium decorated in the "semi-atmospheric" style of the 1930s, which attempts to bring the outdoors in through the use of fake foliage and wildlife; and three working curtains that open to reveal an actual movie screen. Nine authentic movie seats were originally bolted to the floor of the auditorium. There was a projection booth with 16-mm projectors, an organ alcove complete with a working organ, and a small chapel. Not only did Gordon design, build, and decorate the space, he also did all the electrical wiring and installed more than nineteen audio speakers into hidden panels in the ceiling and the walls, making it possible for the organ music that he so loved to flood the space.

Gordon designed, constructed, and decorated his theater with a meticulous attention to detail that some might say bordered on obsession. He continuously redesigned and changed its layout over the years. Upon close inspection, a visitor to the Shalimar would be struck by his use and adaptation of mundane household items, such as plastic night-lights, which were used as foot lights on the stage, or lawn ornaments that were faux-painted by Gordon to blend into the auditorium surroundings, evoking feelings of opulence and grandeur. In this regard, his creation was not so far removed from the palaces that inspired him, which were often built with elaborate facades designed to enchant and transport the audience. Given the time and commitment Gordon made to build the Shalimar, it is surprising that he did not use his basement theater to regularly show movies to friends and family. After all, the projection room was

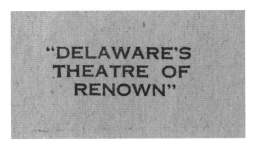

"Delaware's Theatre of Renown," calling card by Gordon Brinckle

"Delaware's Theatre of Renown," text by Gordon Brinckle

outfitted with a working 16-mm army issue RCA projector, special effects lights, and stereophonic sound. But what compelled Gordon to construct the Shalimar was not only his dream of owning a movie theater but also his interest in preserving the history of movie palaces. In his writings about the Shalimar he views his "theatre of renown" as a museum dedicated to this history.

History and storytelling are also central to my work as an artist. I generally commit years to each individual project, ultimately creating exhibitions of still photography, film, and video to preserve and share stories that would otherwise go unheard. I am most often drawn to the stories of aging individuals, so a sense of urgency propels my work, since the people that I choose to work with are often in their final years of life.

The Projectionist follows in this tradition. My initial work with Gordon consisted primarily of still photography. I began making images of him in late 2001 and continued until he and his wife passed away within a month of one another in late 2007. Initially, all of the photographs were portraits of Gordon inside the Shalimar or stills of the theater itself, captured in deep, saturated color to augment the palette that Gordon had used in decorating his movie palace. In many of these photographs, Gordon became my muse, dutifully shuffling about in his self-created fantasy world, operating the projector, serving as usher, and performing for his audience. The wildly colored and patterned jackets that he was famous for wearing to greet patrons at the Everett in his final working years became a staple of our collaboration, and the color film fittingly echoed Gordon's zeal and devotion to his theater, highlighting the fantastic secret world that he had created in his basement.

As the project progressed and I spent more and more time with Gordon and Dot, I kept reflecting on the significant differences between Gordon's downstairs and upstairs worlds and began to document his life outside the Shalimar. For these images, I shifted to black-and-white film, in order to evoke the quiet mundanity in the daily routine of an ostensibly unremarkable man not so different from other elderly individuals leading sedentary lives. In addition to

"Delaware's Theatre of Renown," text by Gordon Brinckle

photographing Gordon, I began, together with creative partner Lida Burris Gibson, to shoot a thirty-minute-long video documentary of Gordon telling his story. The film, also titled *The Projectionist*, was completed in 2003.

One of Gordon's biggest concerns was the fate of the Shalimar after his death. He was convinced that the house would be sold and the theater demolished. His ultimate dream was that his creation would live on and be appreciated by a general public. In 2006 I had the idea of saving the Shalimar by removing it from the basement and re-building it as part of a traveling exhibition. The theater could be used to showcase *The Projectionist* documentary and would finally be appreciated by a much larger audience. Gordon loved the idea, and in spite of the difficulties to save a theater that was never intended to be removed, we eventually succeeded. Plans were drafted and the Shalimar was removed and rebuilt piece by piece. On the day of his inspection of the reconstructed theater, Gordon excitedly remarked that he had seen many movie palaces torn down but never had he seen one taken apart and then rebuilt to travel to multiple locations. Seeing his face that day and realizing that I had helped him achieve his dream was one of the most special moments of my life.

In my work I examine themes of acceptance, intimacy, the nature of memory, and the significance of individuals typically passed by. *The Projectionist* explores the questions of what we see versus what we don't see and what we choose to see versus what we don't choose to see. Would we have taken the time to ever engage Gordon Brinckle in conversation? Would we allow ourselves the chance to discover this fantasy world contained in the basement of a modest home? What other stories or self-created worlds are we missing by not engaging our elders?

I believe that Gordon can be an inspiration to all of us for his passion and commitment. But he can also serve as an example of an individual who, like so many others, could have easily been overlooked had we not taken the time to pay attention and listen to his story.

Kendall Messick

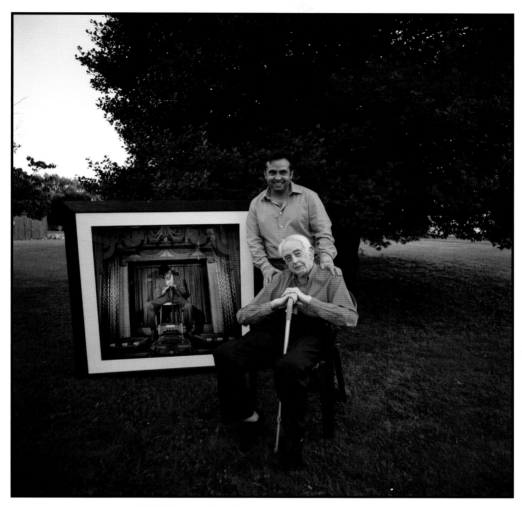

Kendall Messick and Gordon Brinckle, 2006 (photo by Suzanne Forsman)

THE PROJECTIONIST AND THE SHALIMAR THEATRE

Photographs by Kendall Messick

"I was happy in the booth because that is where I belong. They said that as a manager I was pretty good, but I left a little bit to be desired where it came to handling people. But upstairs they said, 'he is born to be up here! He is a born projectionist!'"

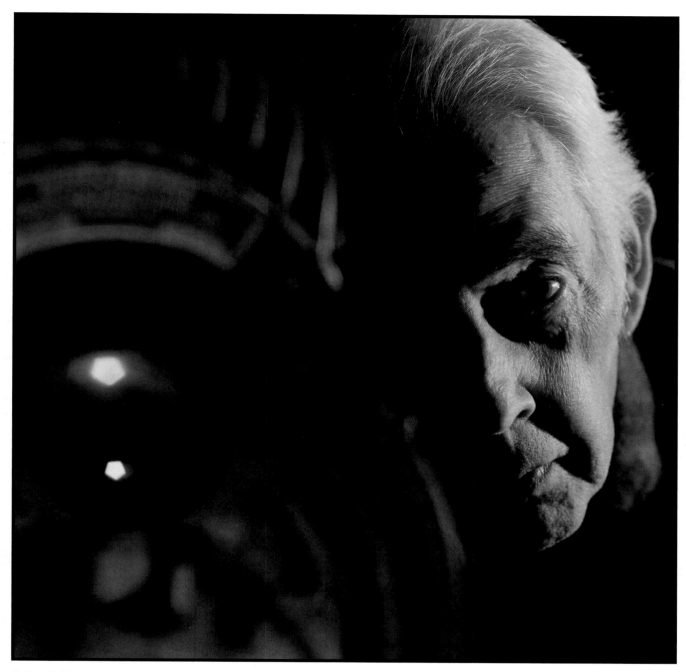

The Projectionist

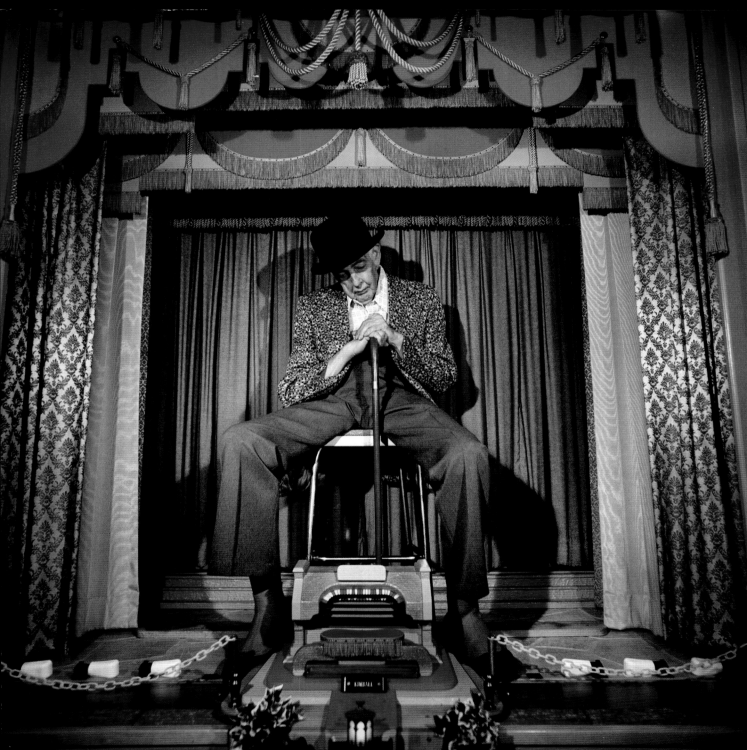

110 East Hoffecker Street

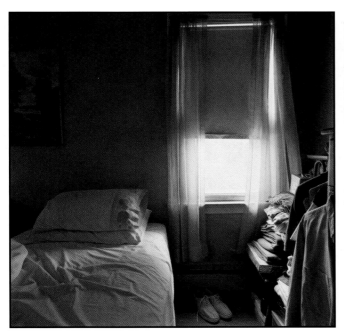

Morning

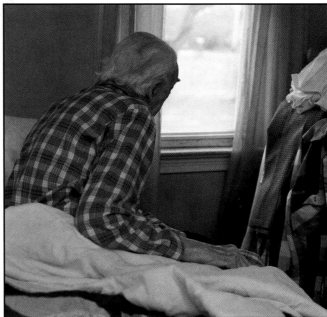

Waking

"The Shalimar is actually a poor man's rendition of a picture palace. As a matter of fact, on the marquee it says 'Delaware's last movie palace.' And it's really the truth. This is about as close as you are going to get to a movie palace today. We do have a marble statue here, and it is from Italy. And we have two marble statues on the stage, which is class!"

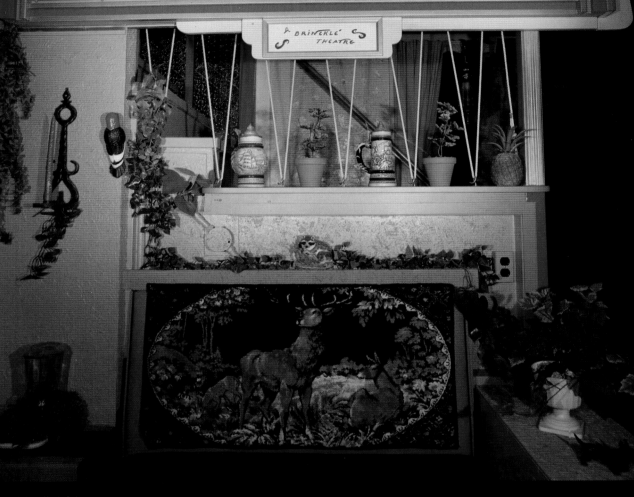

Delaware's Last Movie Palace

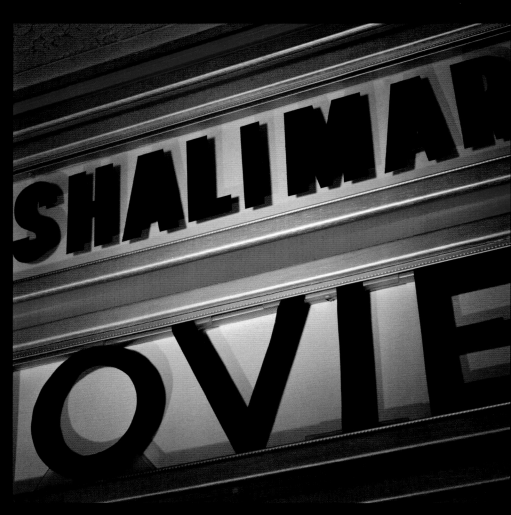

Shalimar Marquee Detail

opposite:
Shalimar Drape Detail

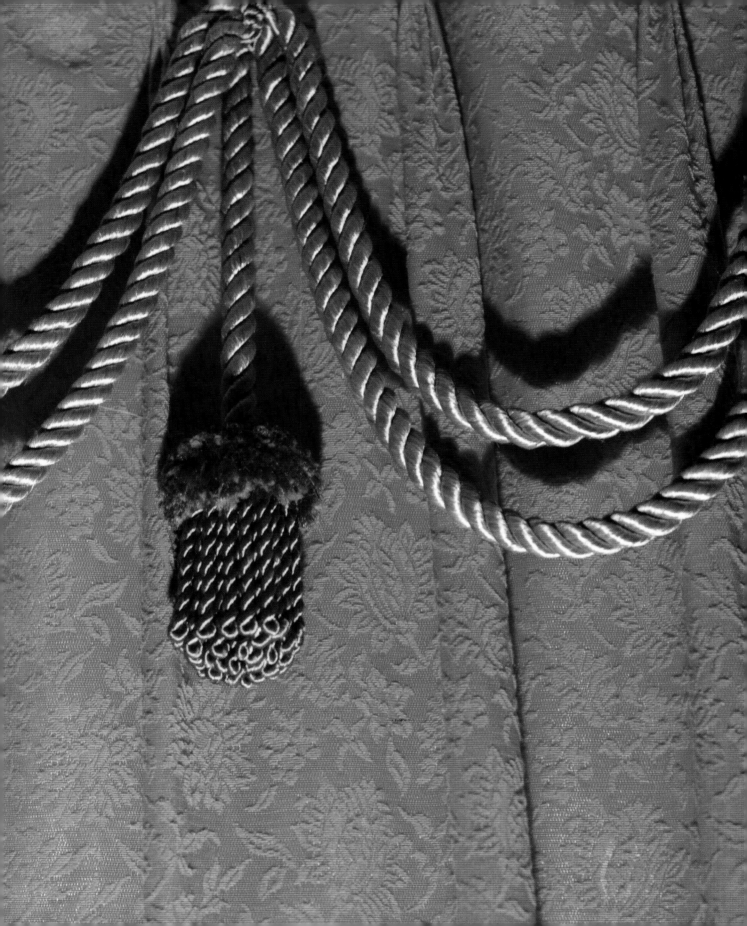

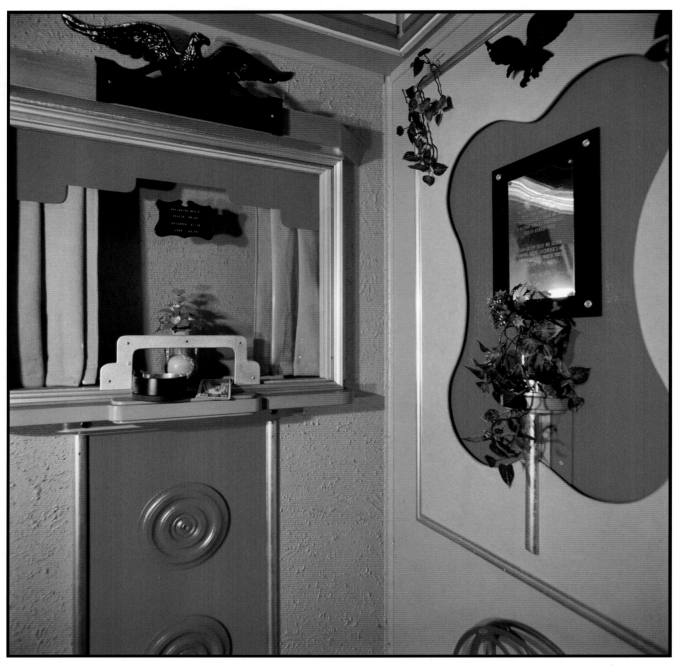

Shalimar Box Office

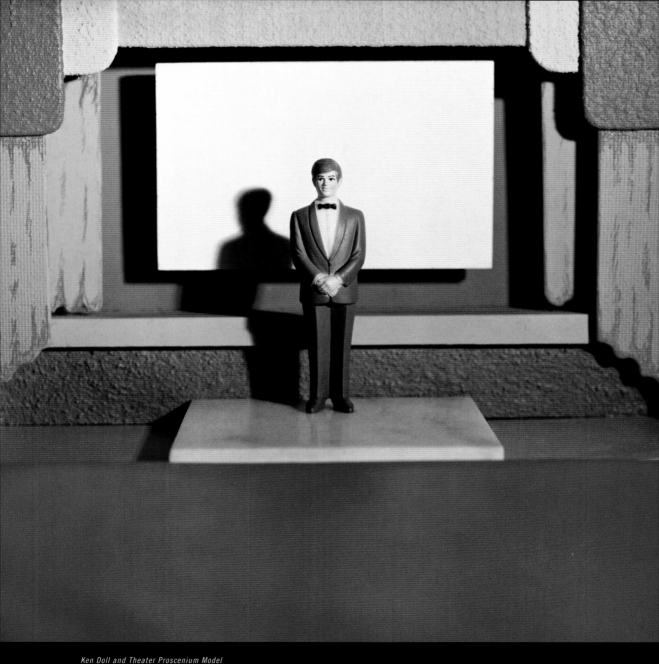

Ken Doll and Theater Proscenium Model

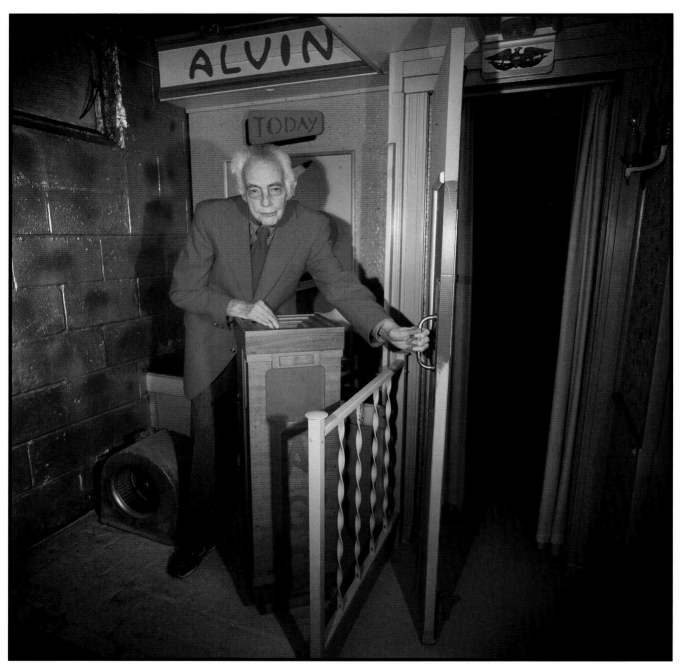

Ticket Taker

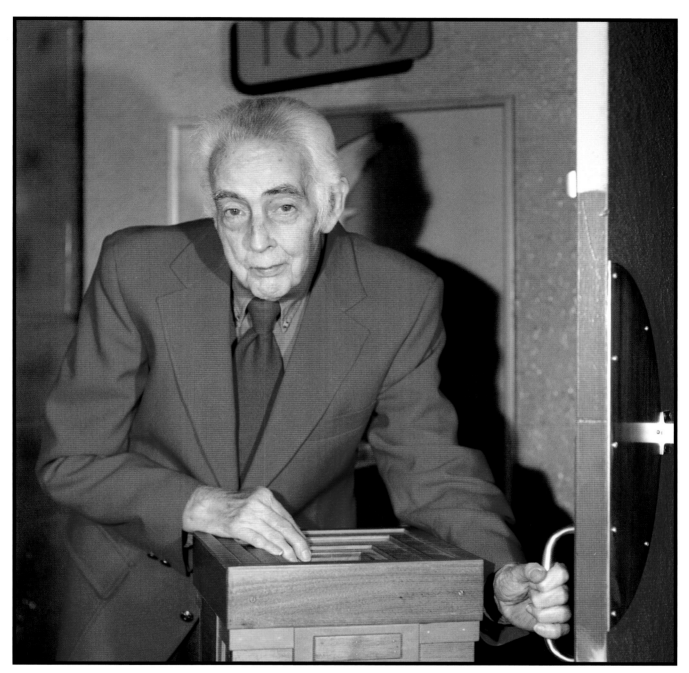

Welcome

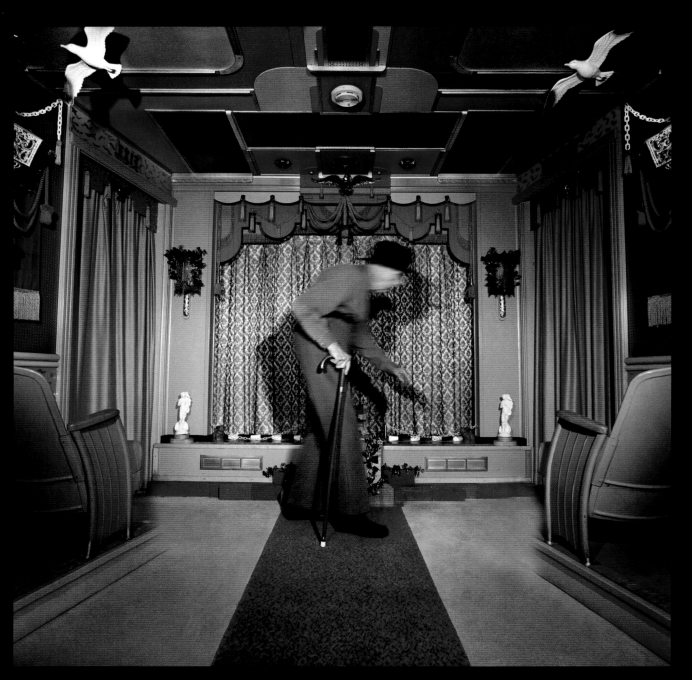

Act I

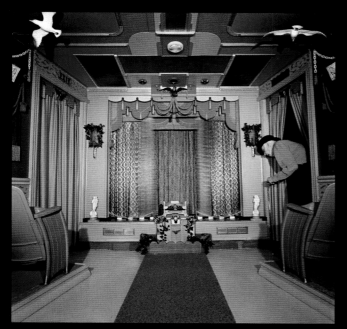

Act II

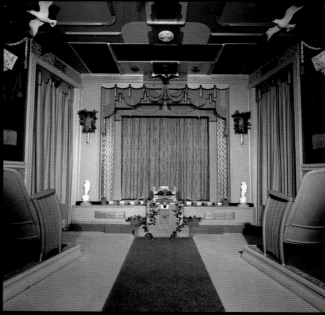

Act III

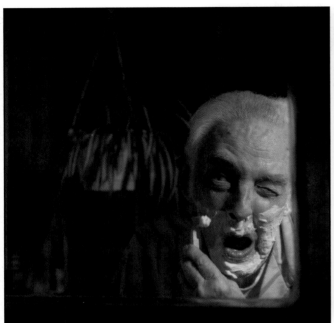

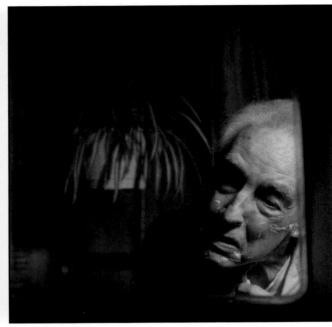

Shaving II

Shaving III

opposite:

Shaving I

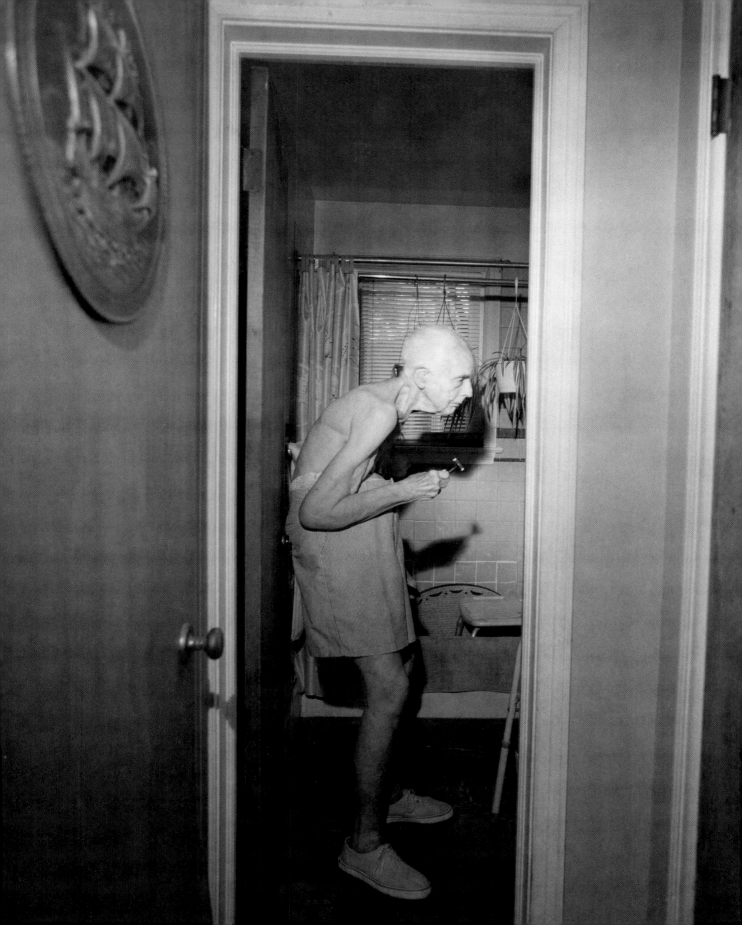

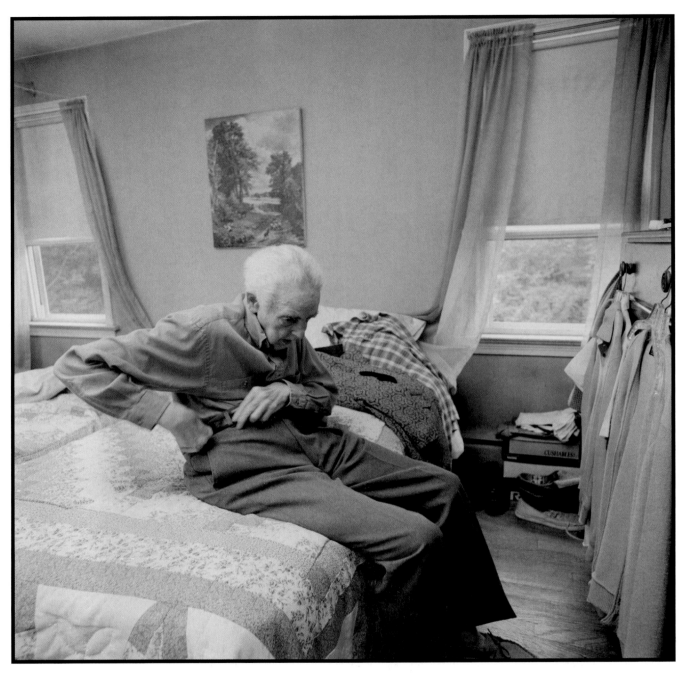

Getting Dressed

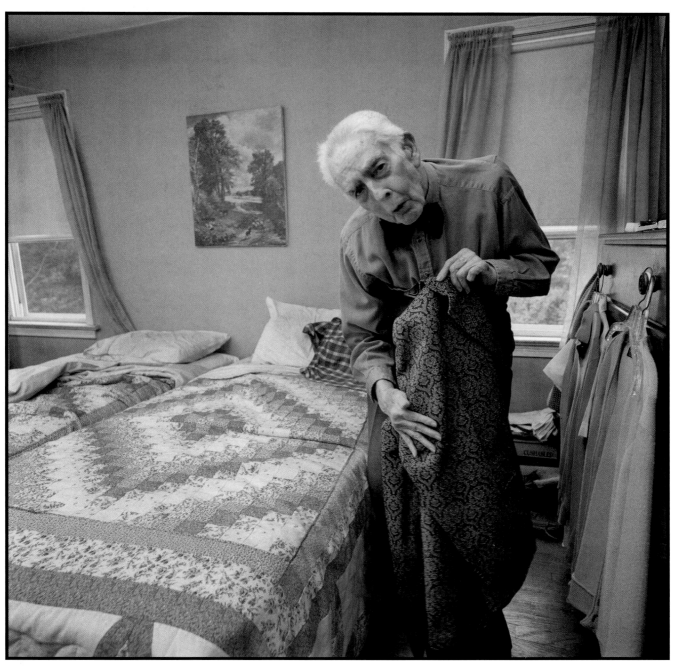

Getting Ready

"I could hear people laugh when they laughed. I could hear them clap, of course, but otherwise, I couldn't hear them. But the smiles on their faces— it's just a certain feeling: you get to know whether the people were happy or not. It's a great thing to be able to do it with a piece of film, a light source, and a lens."

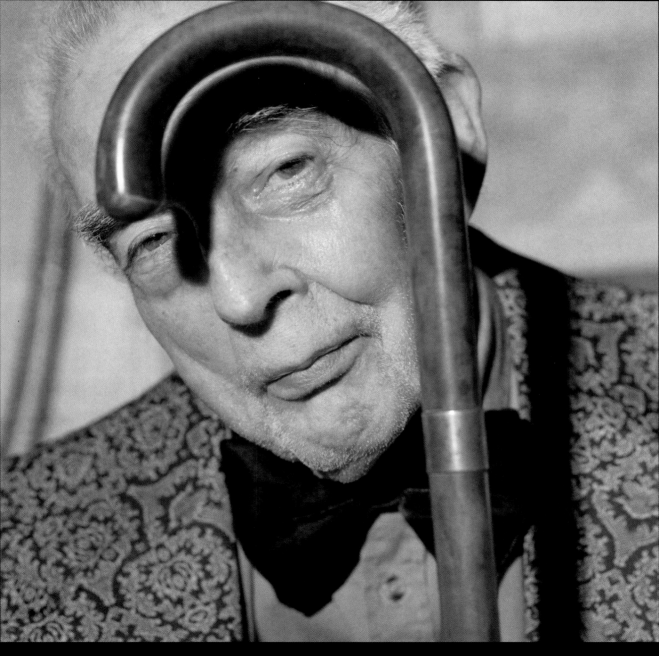

Gordon

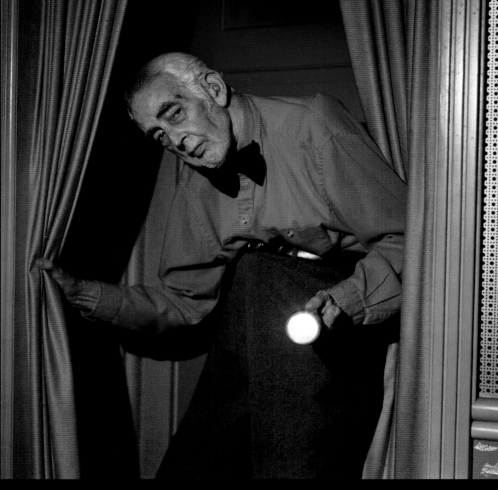

Aisle Jockey

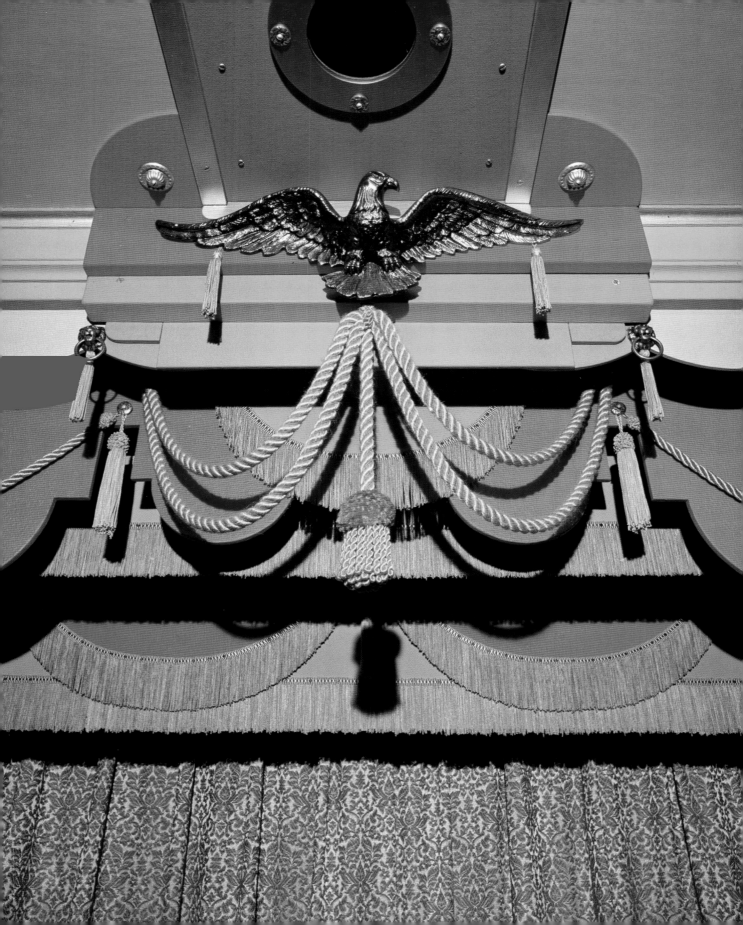

"It [the Shalimar] is in so many different styles that I can't really describe it.…Actually, it's supposed to be an atmospheric theater. When you sat in an atmospheric type theater, you thought that you were in an Italian garden, an Egyptian garden, or most any kind of a beautiful garden where there were fountains. There were fountains in them, and all kinds of things—trees, all fake, and ivy draped around the organ chambers."

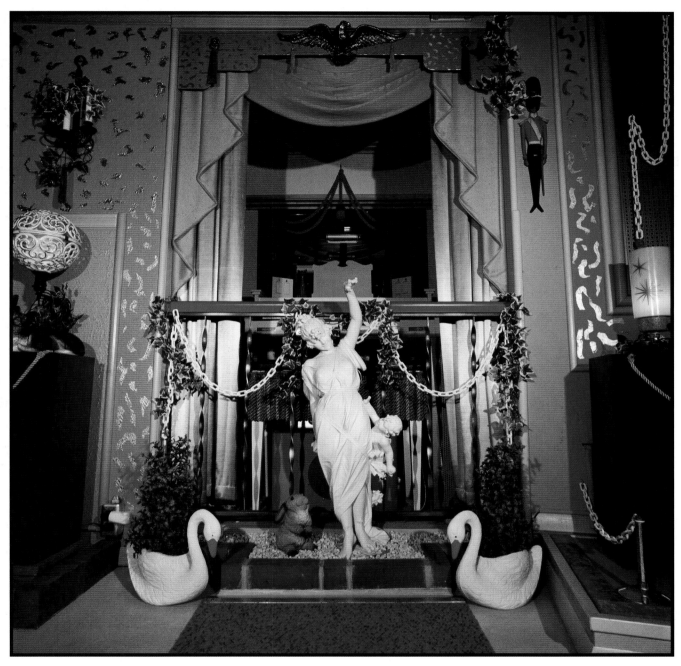

The Shalimar Organ Alcove

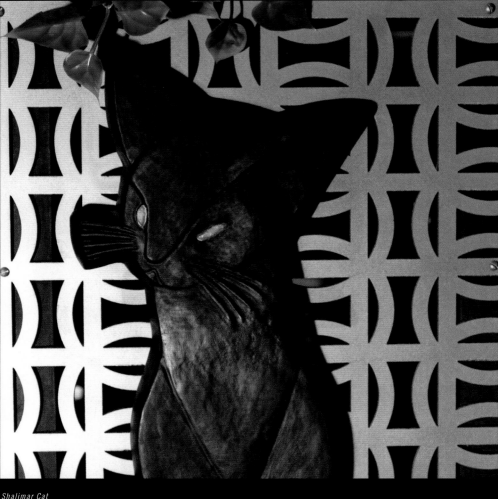

Shalimar Cat

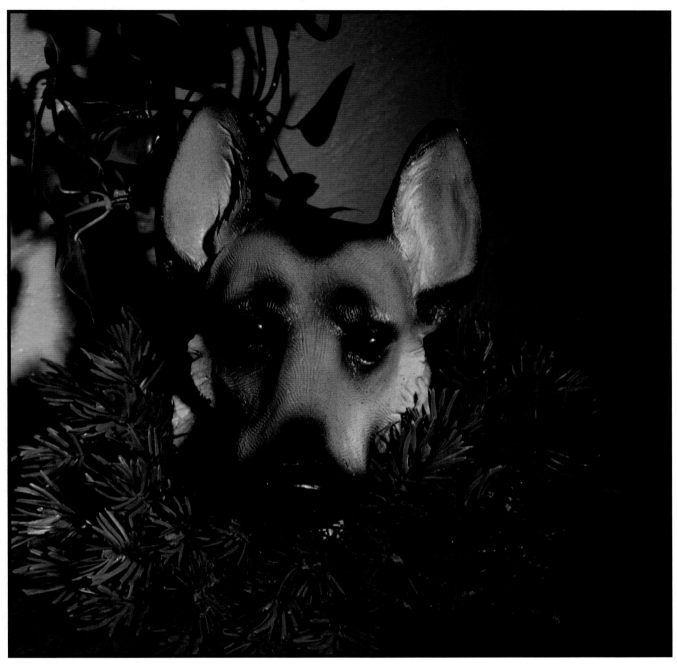

Butch

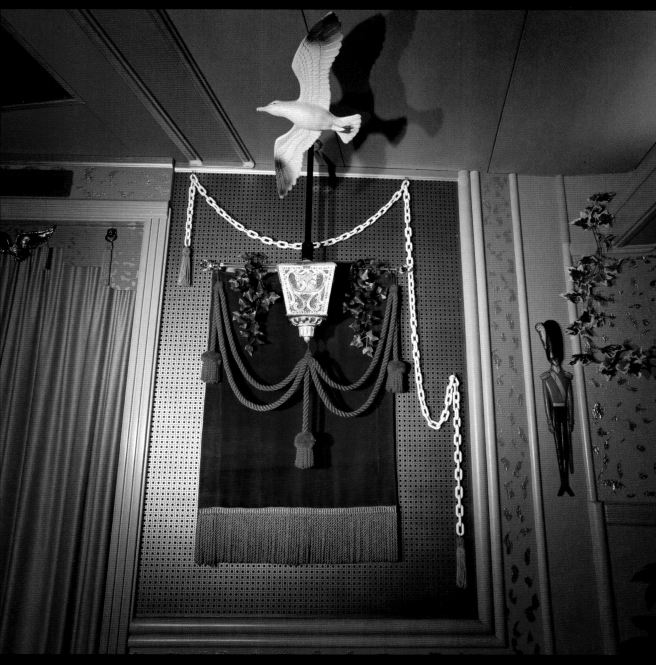

Shalimar Side Wall Detail

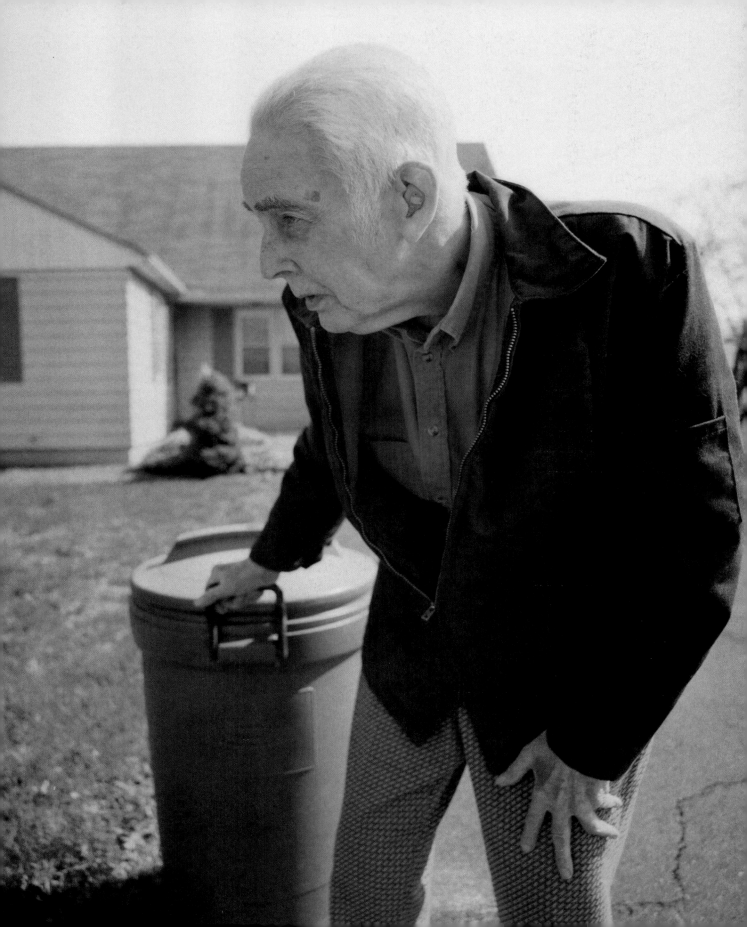

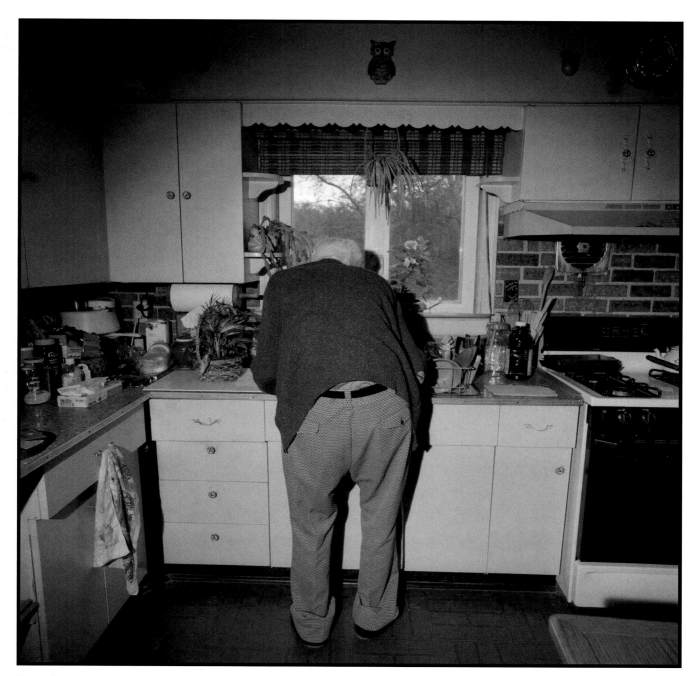

Washing the Dishes

opposite:

First Impression

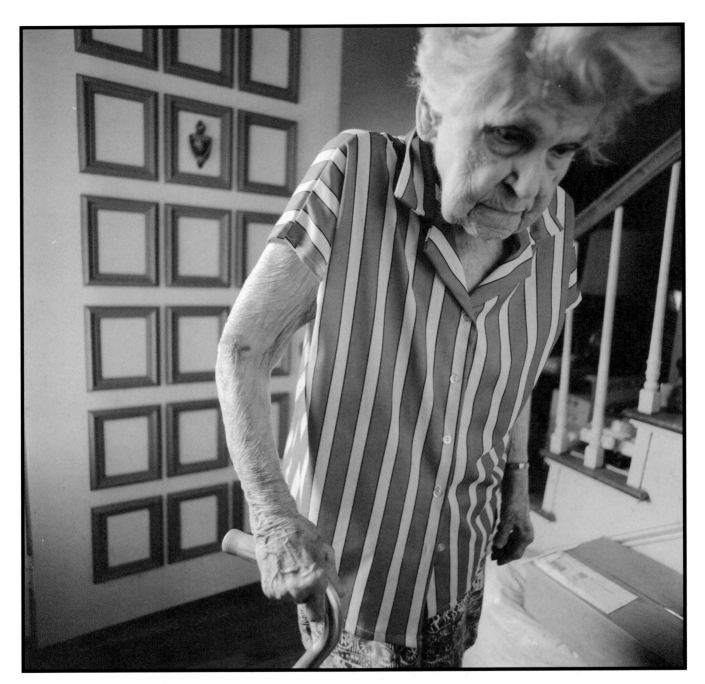

Dot

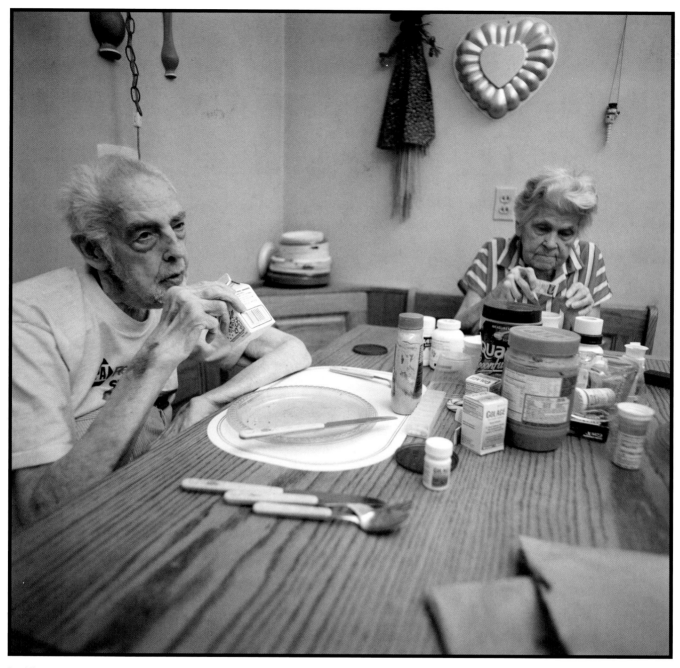

Lunchtime

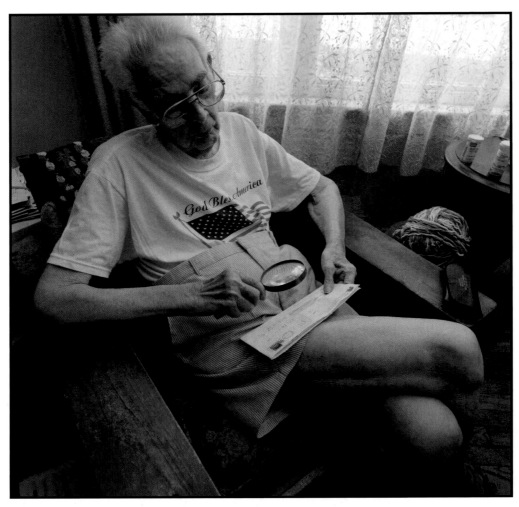

Reading the Mail

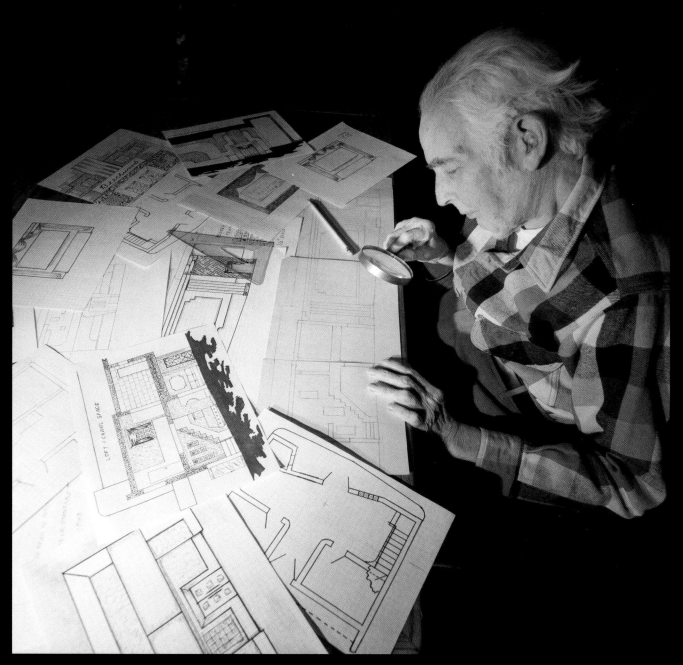

Working and Reworking

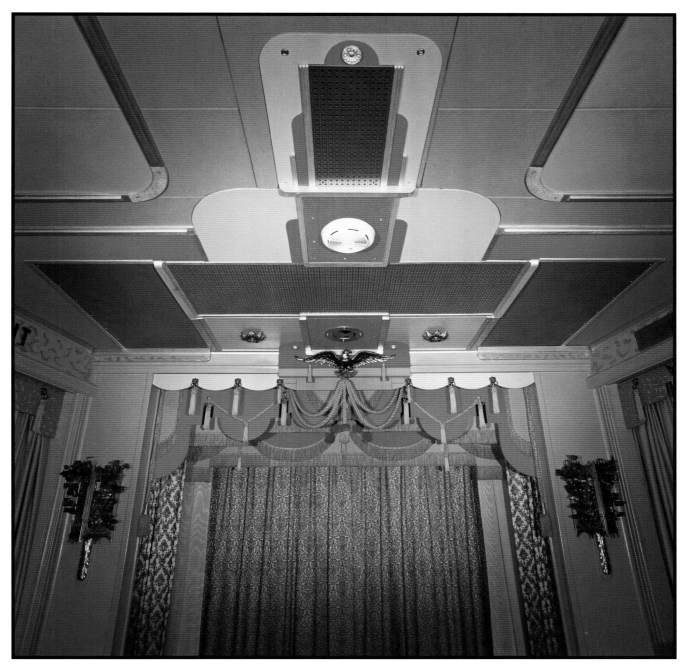

Shalimar Proscenium and Ceiling Detail

opposite:
Now Playing

"The stage is, as I say, very ornate, maybe too much. I know that my boss would say, 'kid, don't you think that is a little heavy?' But I'd say, 'yeah, but it looks good, doesn't it?'"

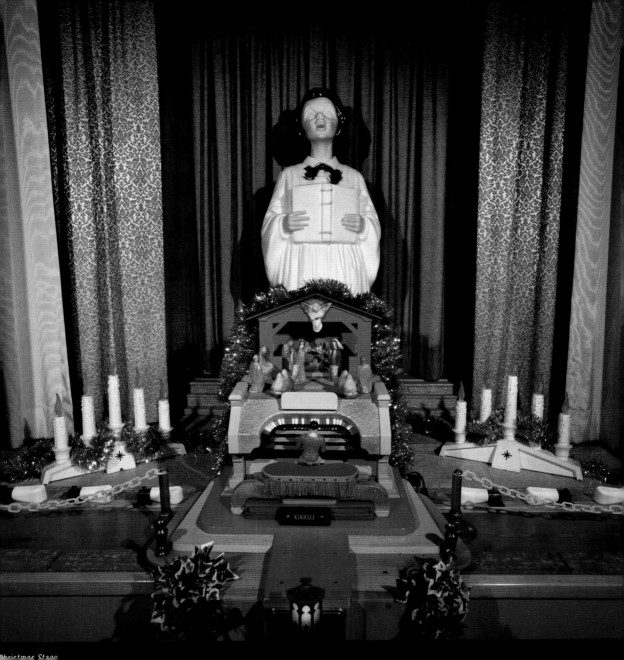

Christmas Stage

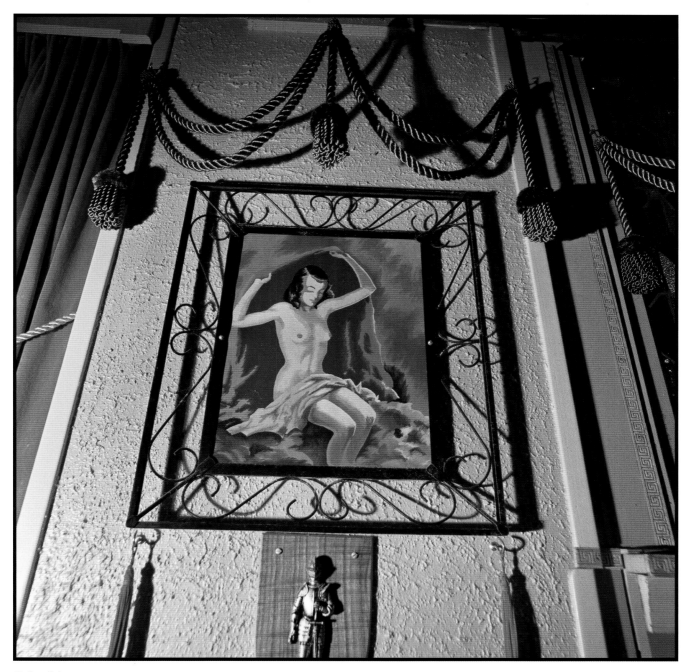

Shalimar Nude

opposite:

Shalimar Dedication

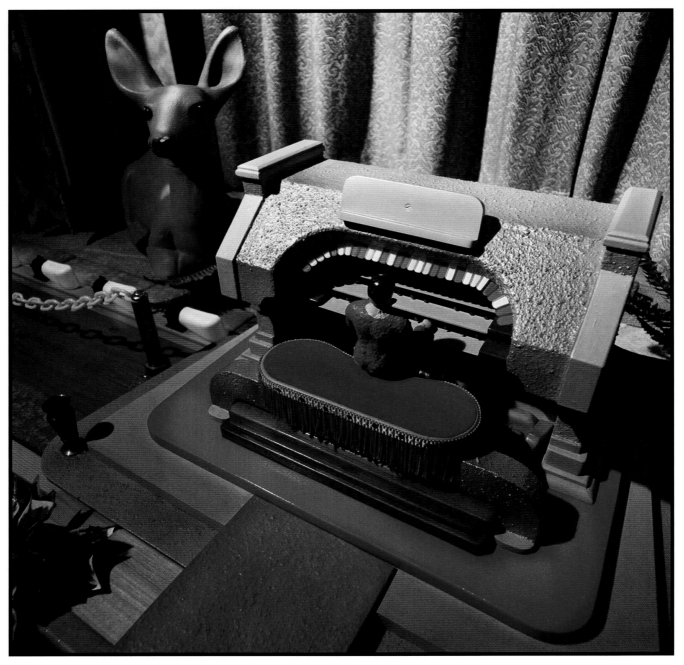

Little Kimball

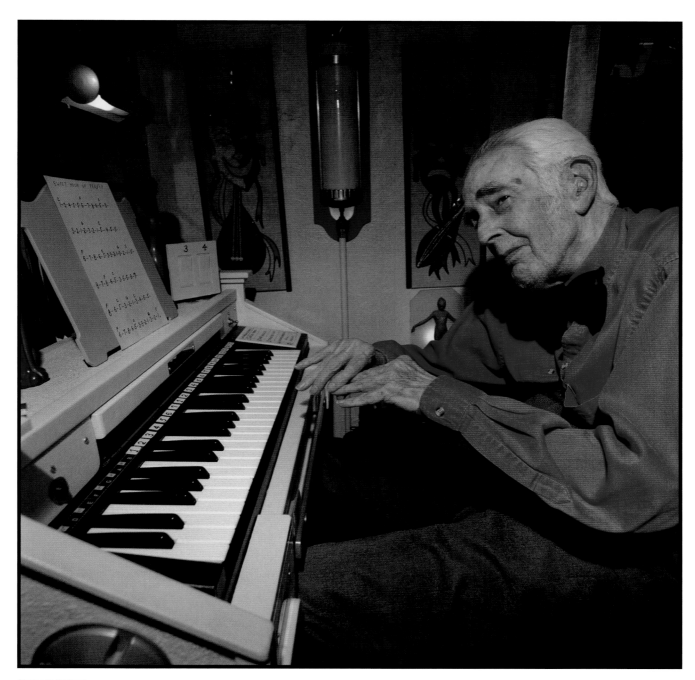

Playing by Numbers

overleaf:

Waiting in the Wings

"In this house, as small as it is, you will see what a picture palace was like: marble, on the stage and off the stage, you have your little Kimball organ there, and all the fixings. We have three different drapes here that work."

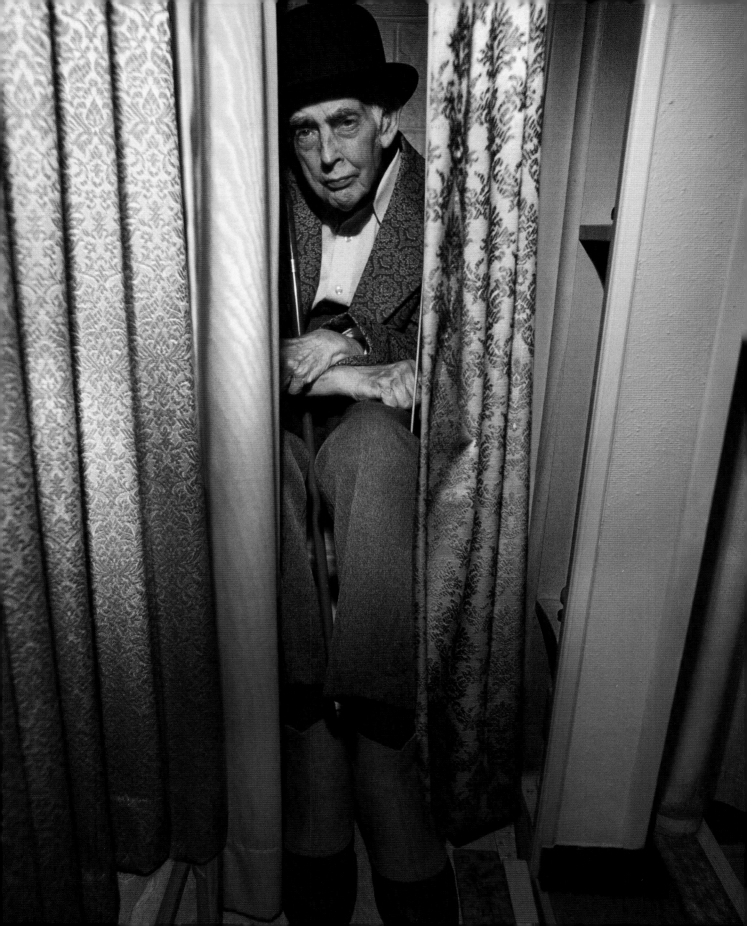

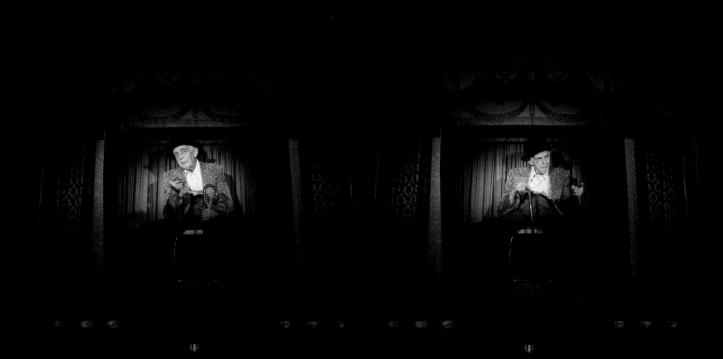

Vaudevillian I *Vaudevillian II*

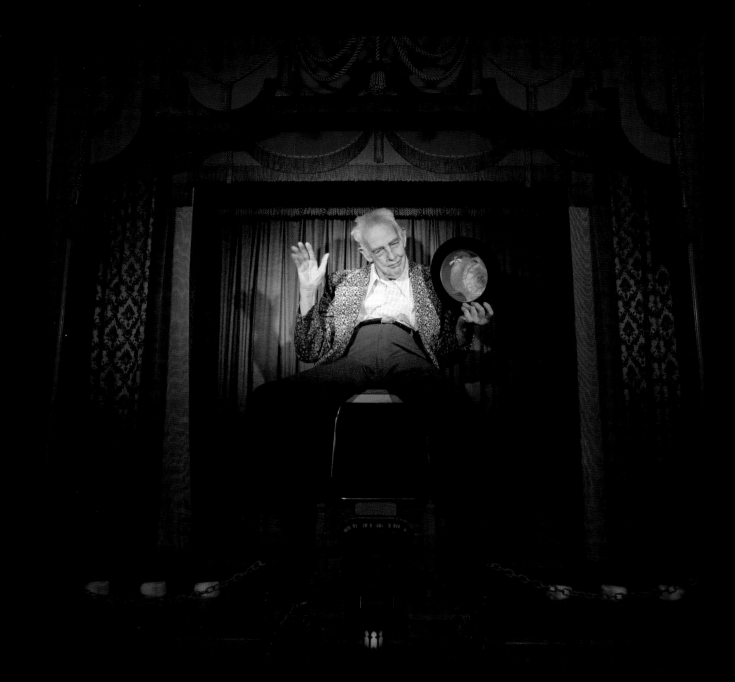

Vaudevillian III

overleaf:
Homage to Hiroshi Sugimoto

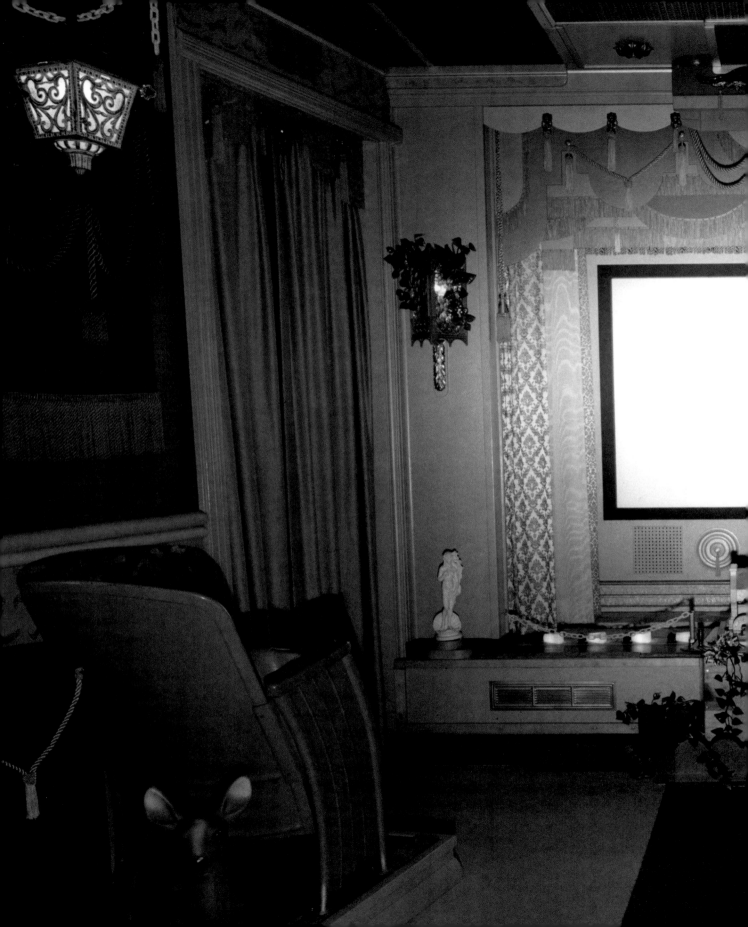

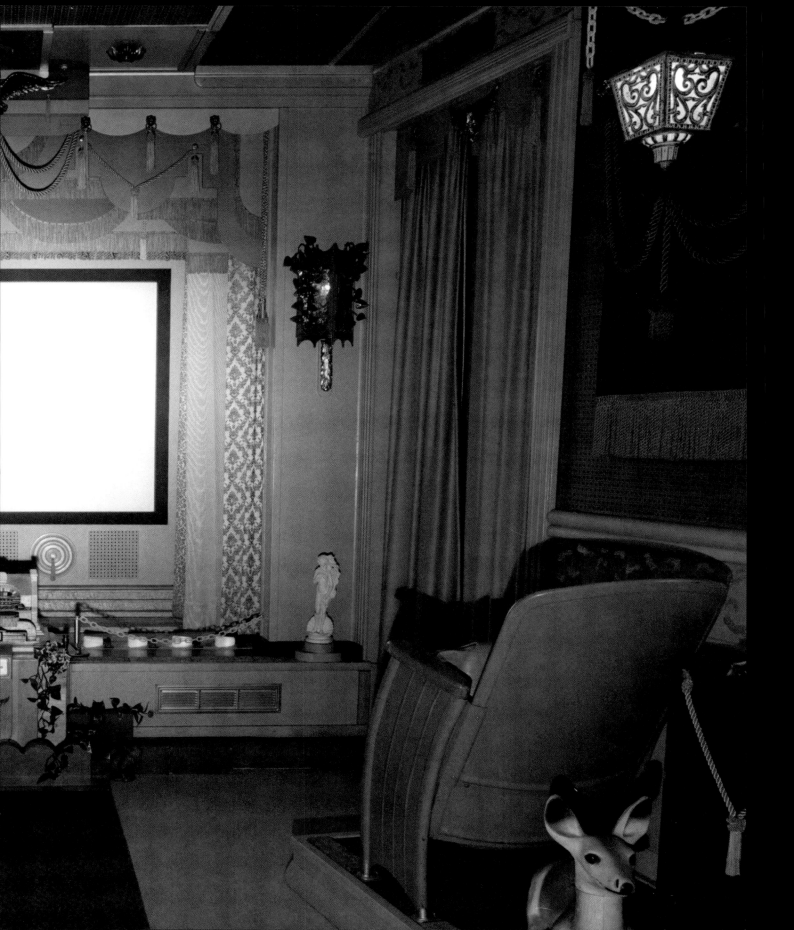

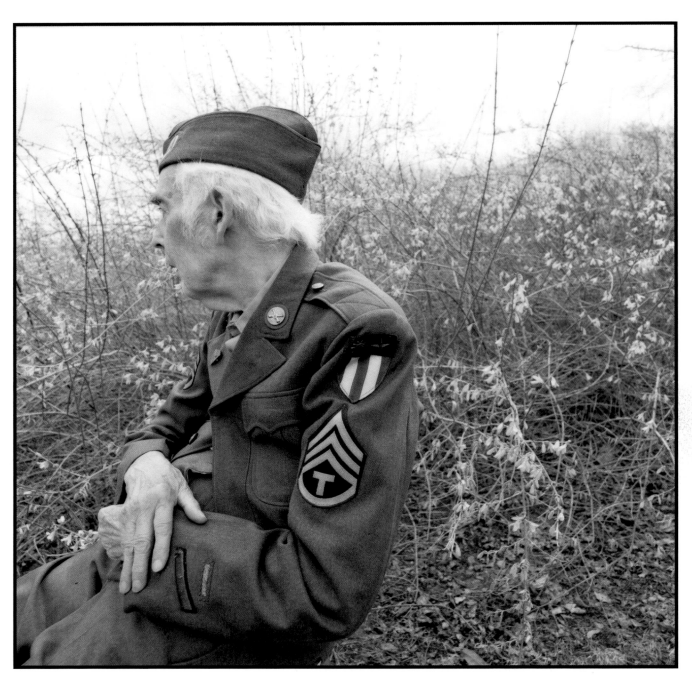

WWII

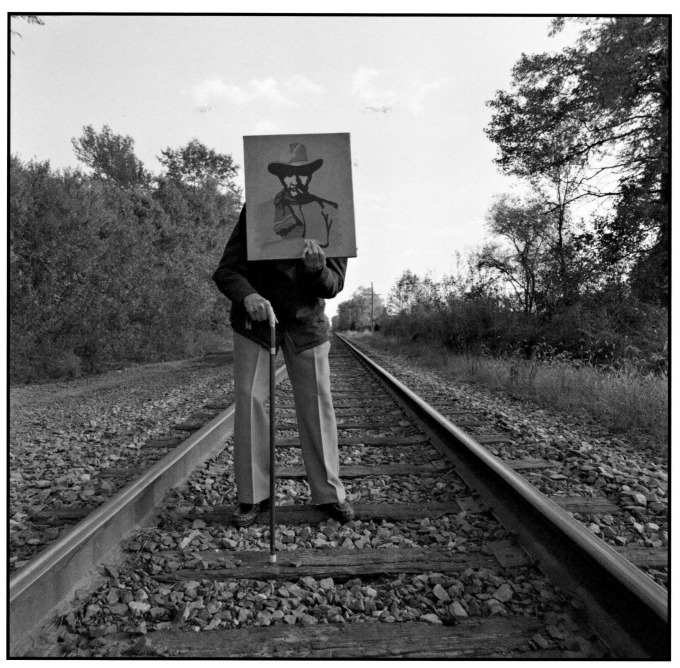

Black Bart

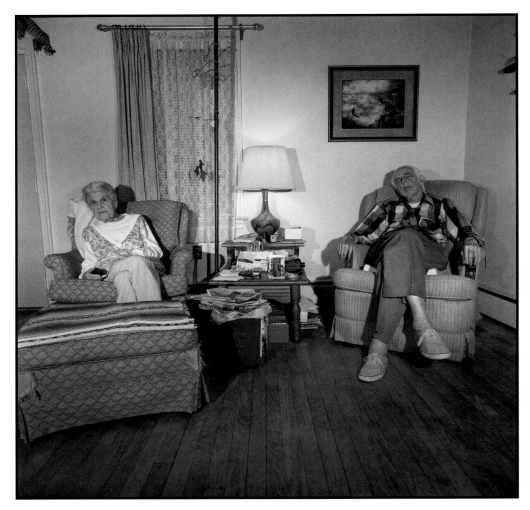

Watching Television

opposite:

The Movie Man

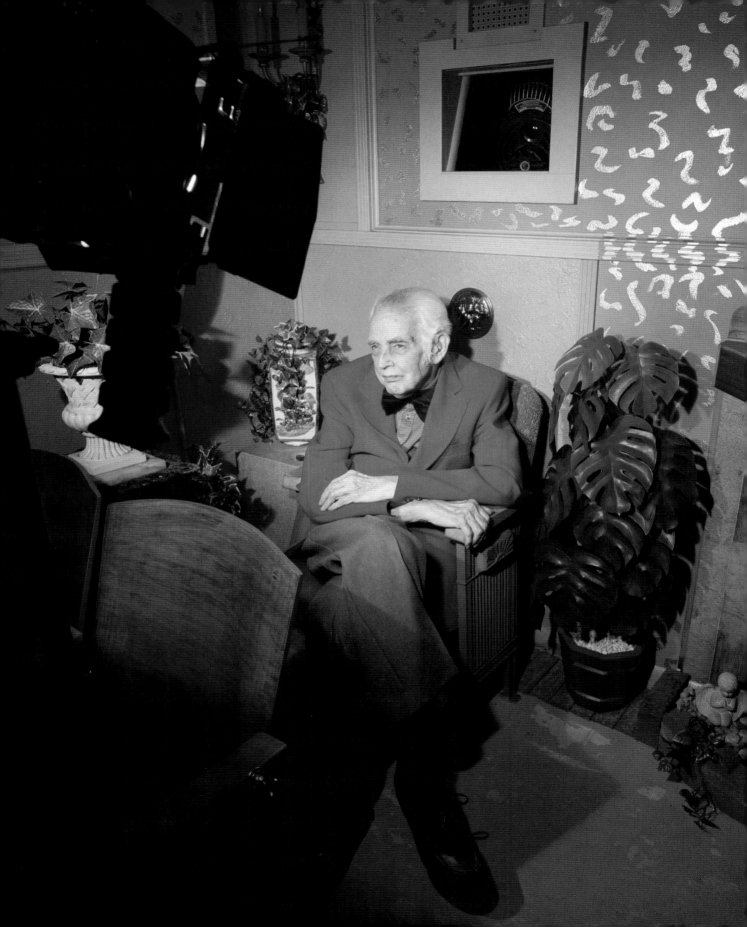

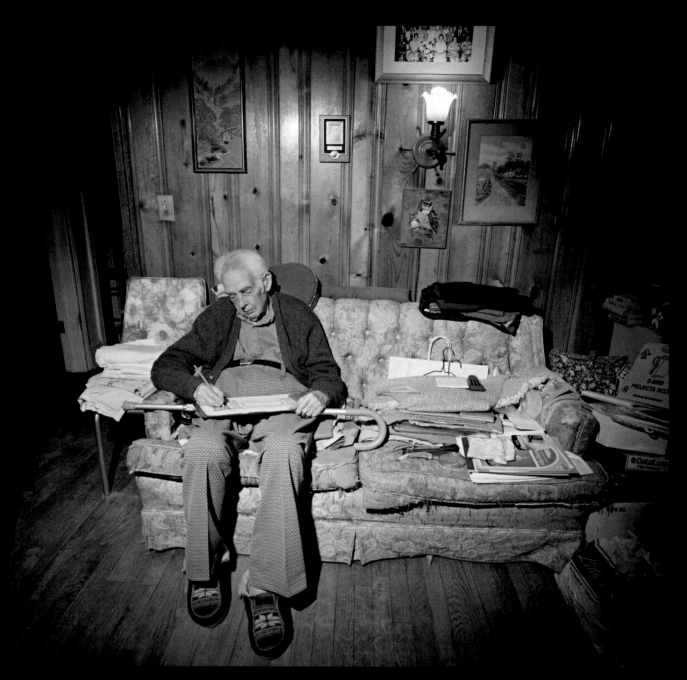

Sketching

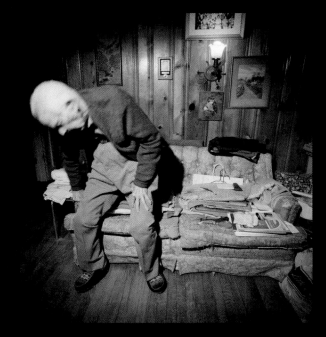

Rising

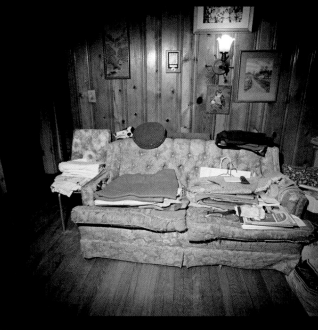

The Den

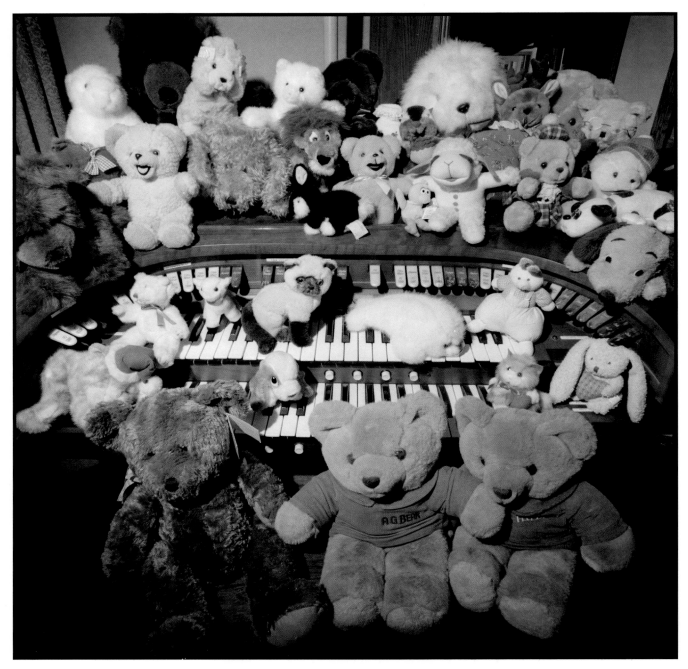

Teddy Bear Collection

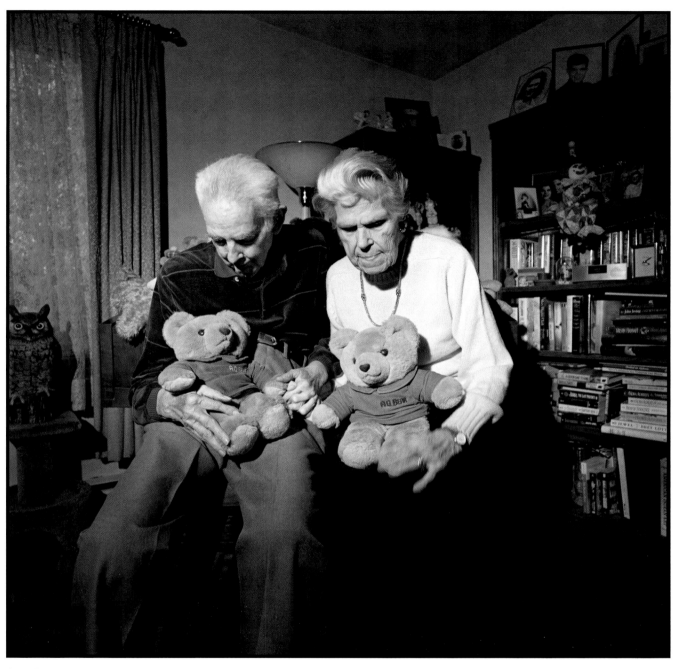

Gordon, Dot, and the Bears

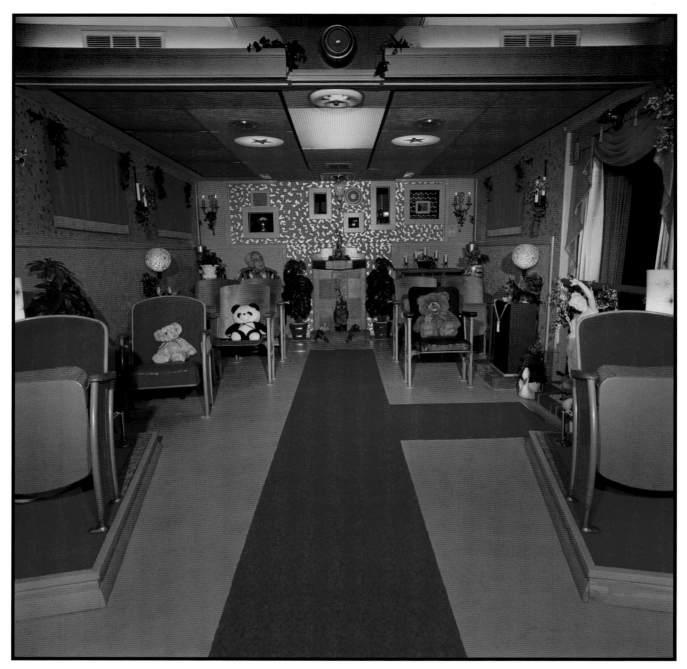

Shalimar Auditorium

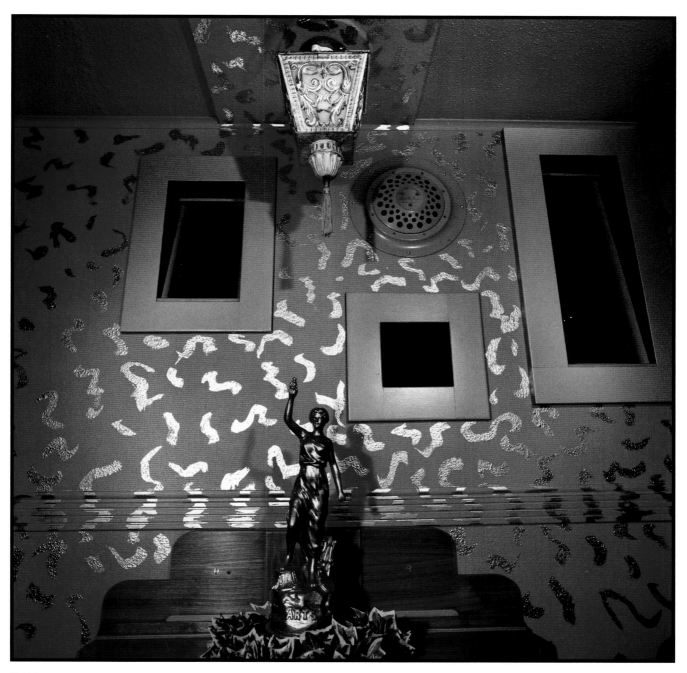

MaryAnn

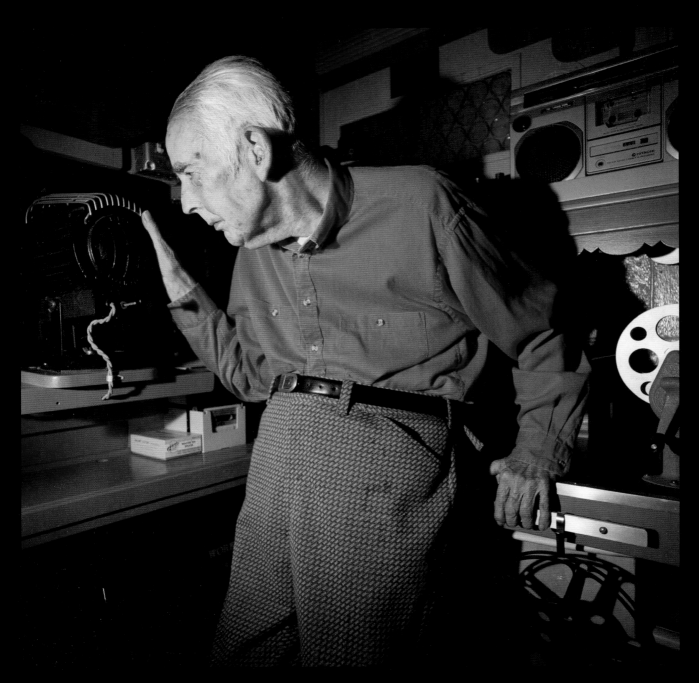

The Operator

"A couple people that saw me work said to me, 'you work like a dancer. You go between the machines, you don't rush, you don't hurry, but you are always doing something.' And it comes to you like a dancer.... You get the rhythm to it. And when something goes wrong, the rhythm goes all to pot."

"It [the Shalimar projection room] is very small. That's for sure. It's built the same as a projection room would be in the past, except this would all be behind a wall. There would be a flat wall here, just the box showing."

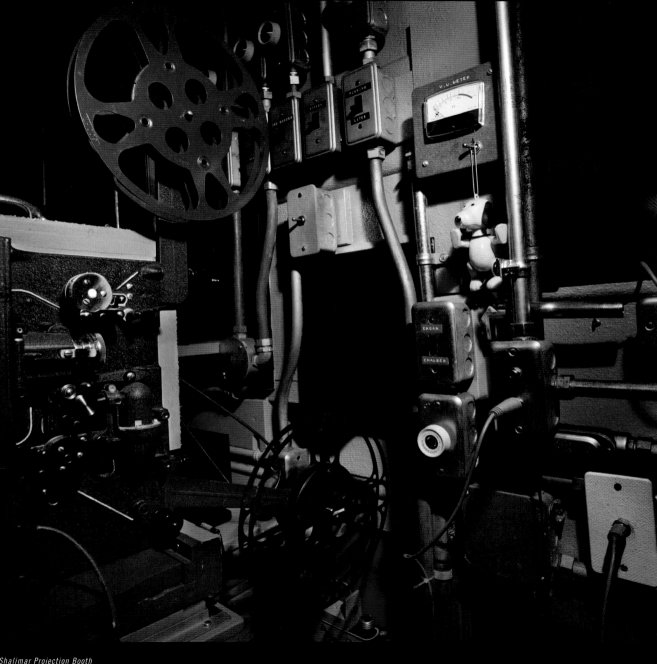

Shalimar Projection Booth

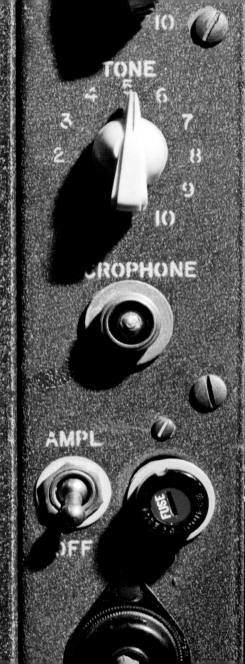

TONE

10
6
5
4
7
3
8
2
9
10

CROPHONE

AMPL

OFF

FUSE

R-EQUIPMENT

SERIAL
2109

60 1250
CYCLES WATTS

NOTICE INSIDE
ION OF AMERICA

RCA

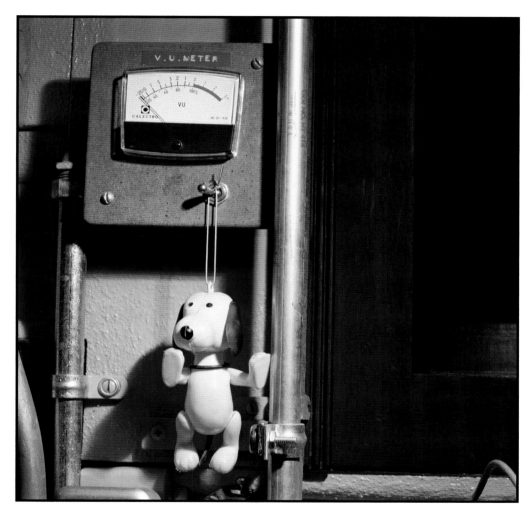

Spotty and the VU Meter

opposite

RCA Projector Detail

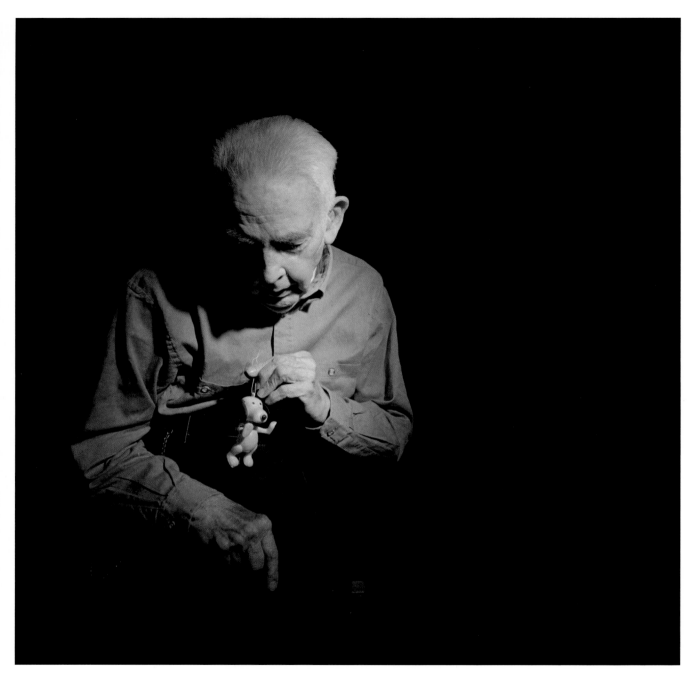

The Mascot

opposite

Untitled

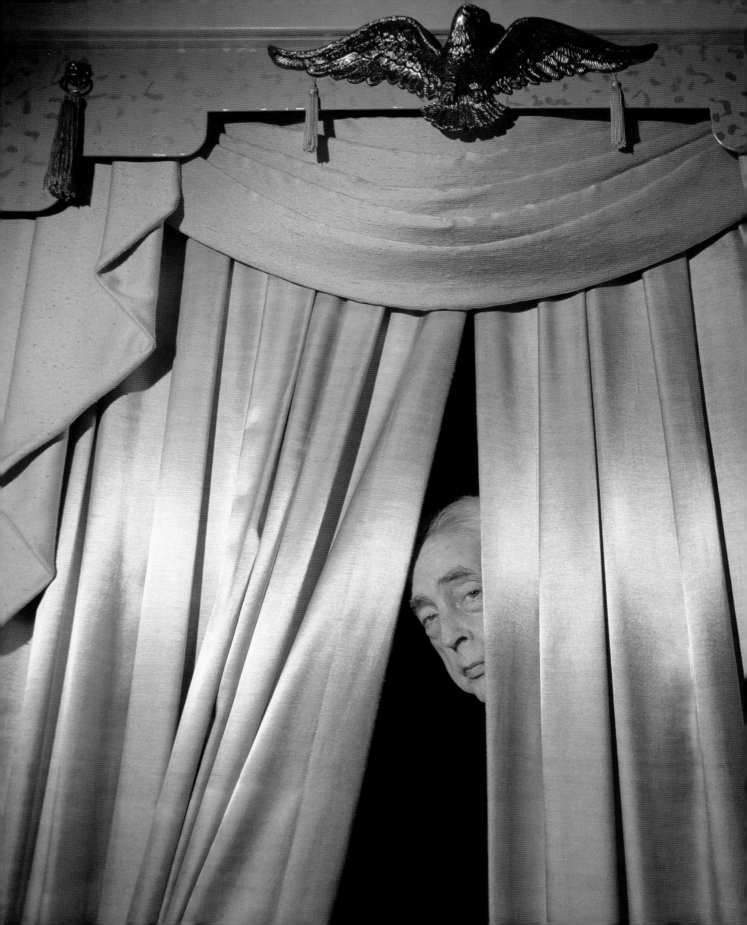

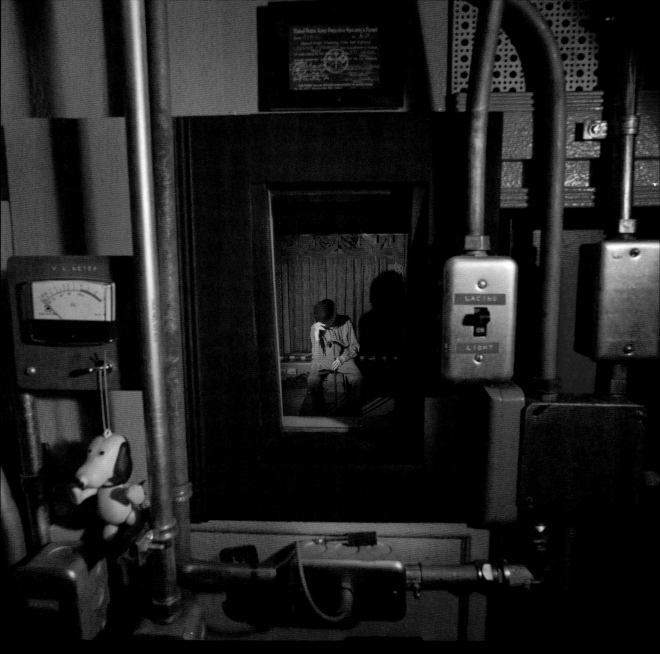

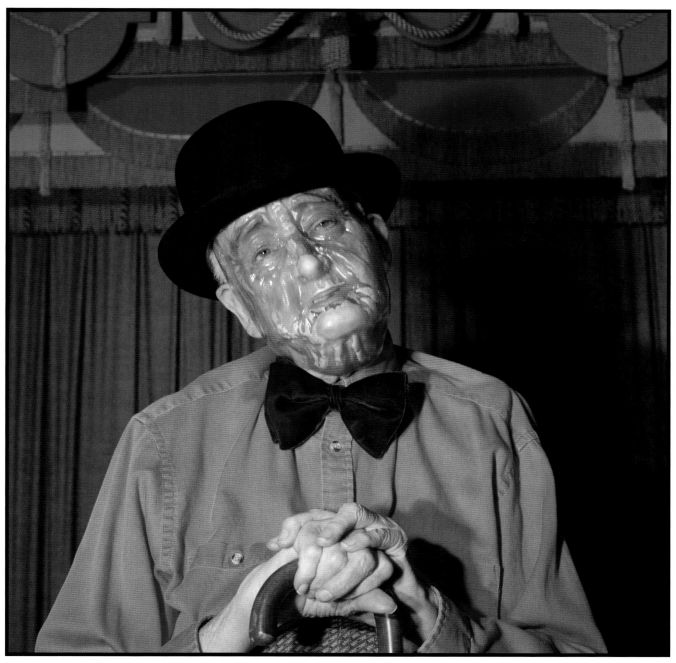

Mask

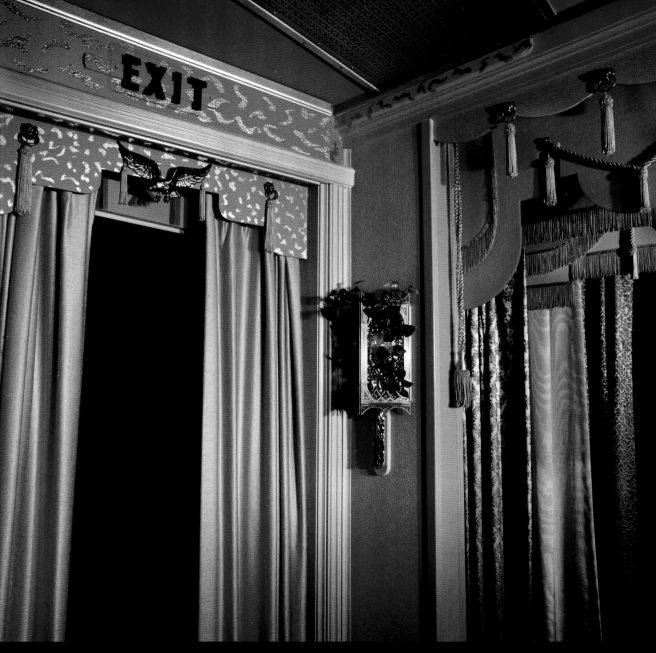

Shalimar Exit

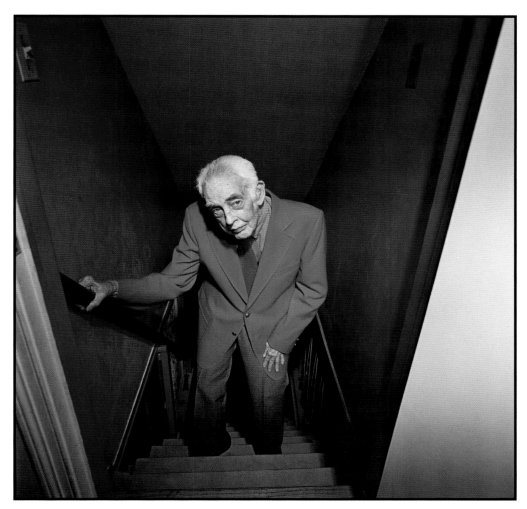

Gordon Leaving

"I come down here, and it is quiet. I just sit sometimes. I don't even think. I just sit. Because it's something beautiful, something I was able to create. God gave me that power, and I've tried to use it. He told me, 'you can't have that big picture house. You'll lose it. But you can build it in your home if you want to.' And I think that is actually the reason that I built the place, that and the fact that I wanted one so badly. So when things went bad at the Everett or something, I came here to the Shalimar and things were all right."

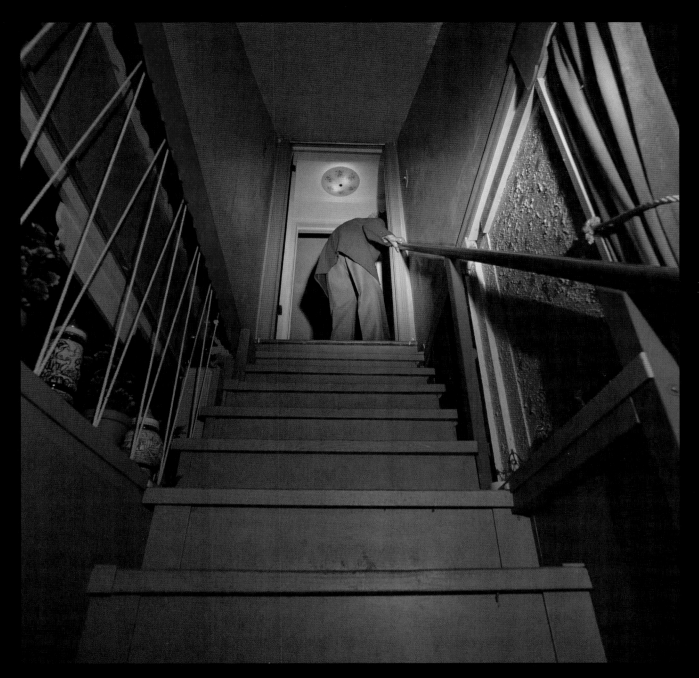

Entrance

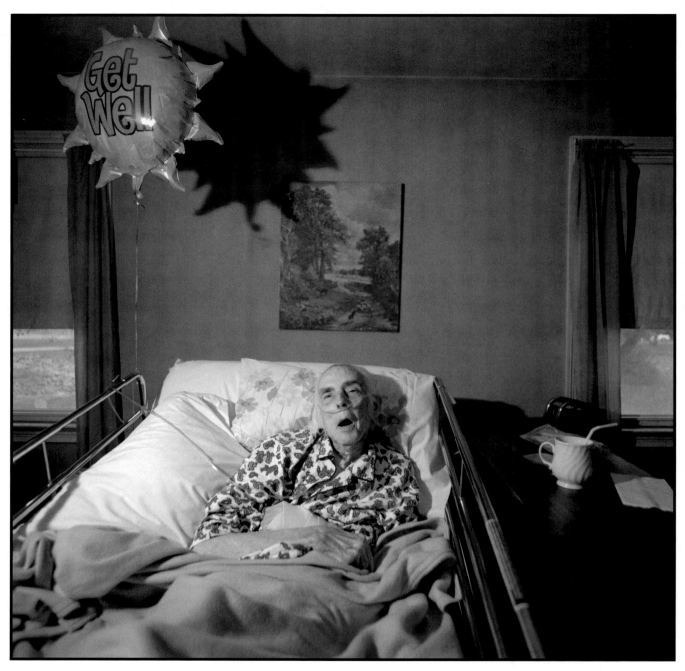

Get Well Soon

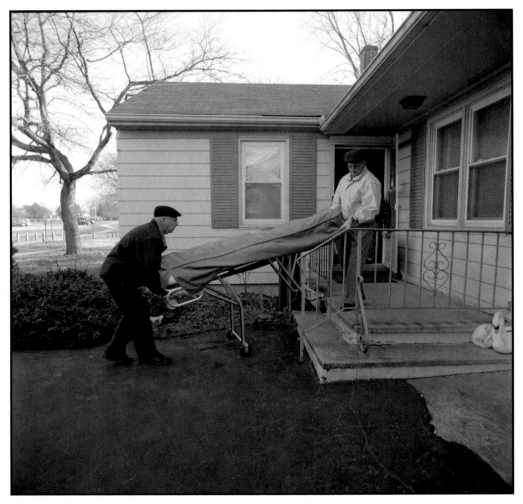

Untitled

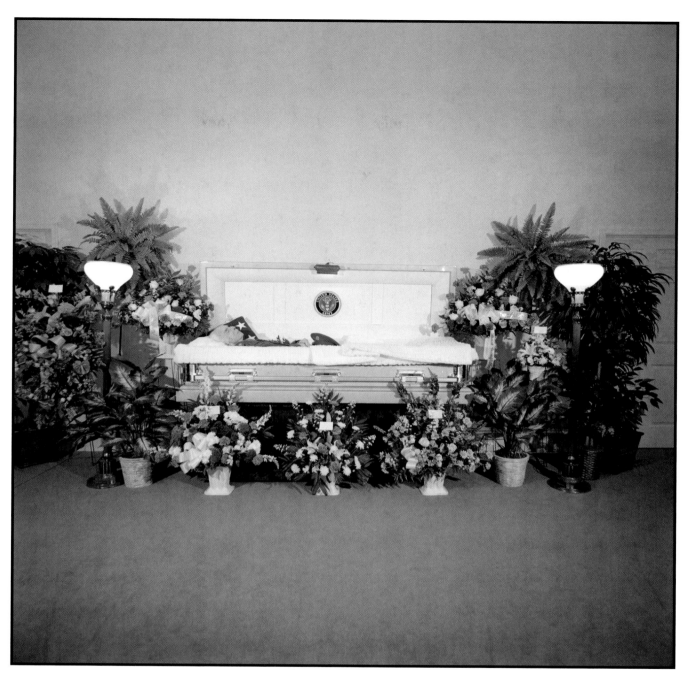

Untitled

"I kept saying, 'it's a shame that when I die, people will come in and break it up and throw it in the trash.' But to know it is going to live on is just wonderful. It is a dream come true."

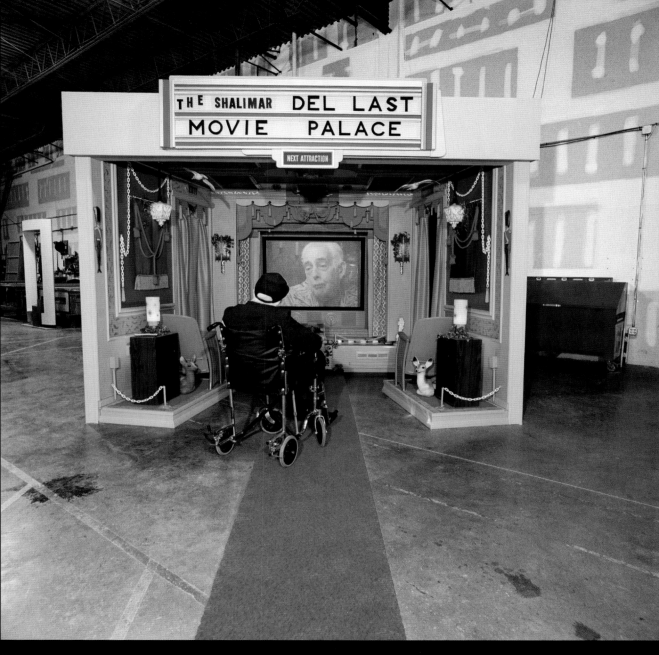

THE SHALIMAR DEL LAST
MOVIE PALACE

NEXT ATTRACTION

Final Inspection

DRAWINGS AND PRINTS

By Gordon Brinckle

*"I drew theaters for so many years
that I cannot remember when I
started it. But I drew them and then
I would build them as small models.
And the models got bigger and
bigger and bigger until the Casino
Theatre was born in the basement."*

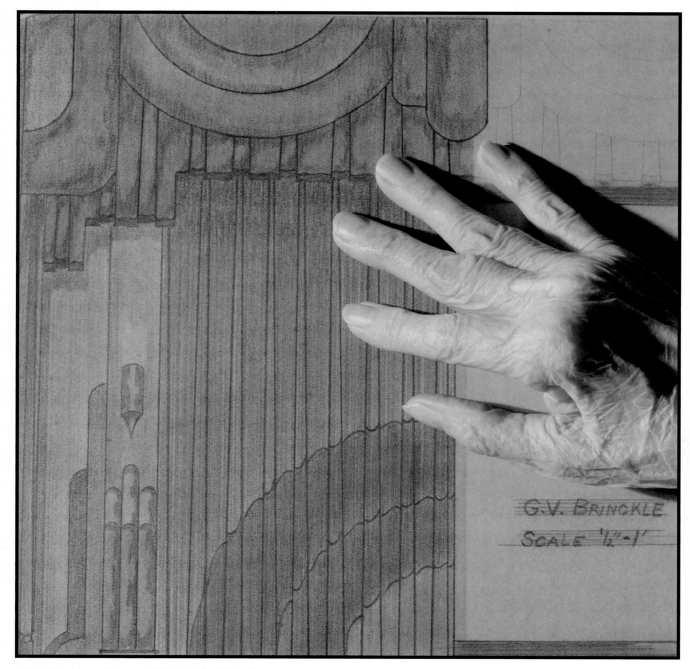

Untitled, Gordon's hand with drawing, 2007 (photo by Kendall Messick)

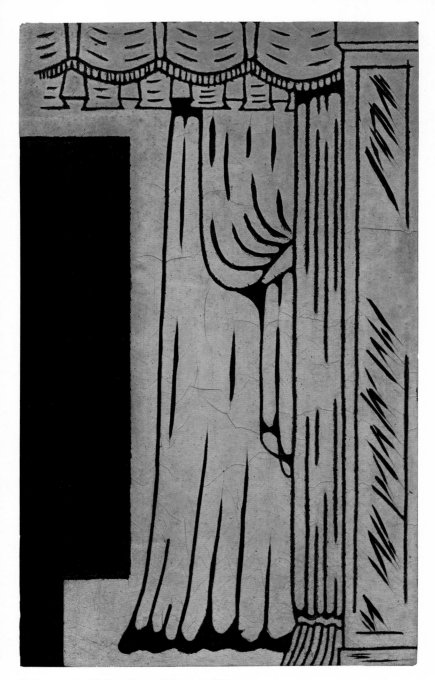

Linoleum block for Alvin Casino Theatre stationery, ca. 1936

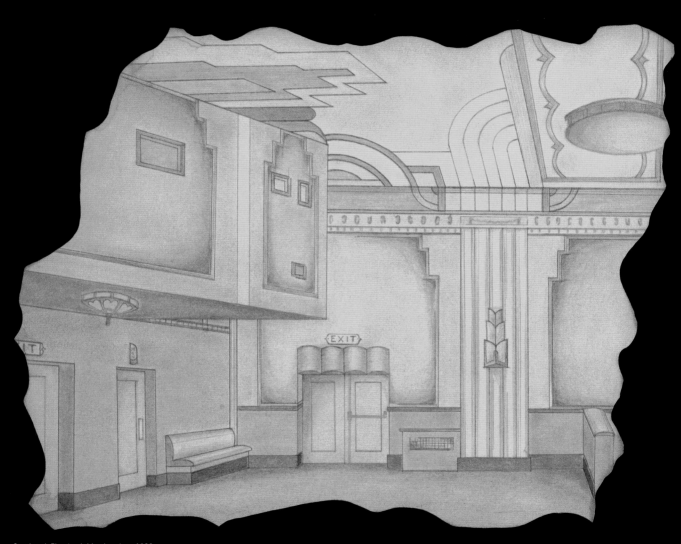

Overbrook Theatre lobby drawing, 1939

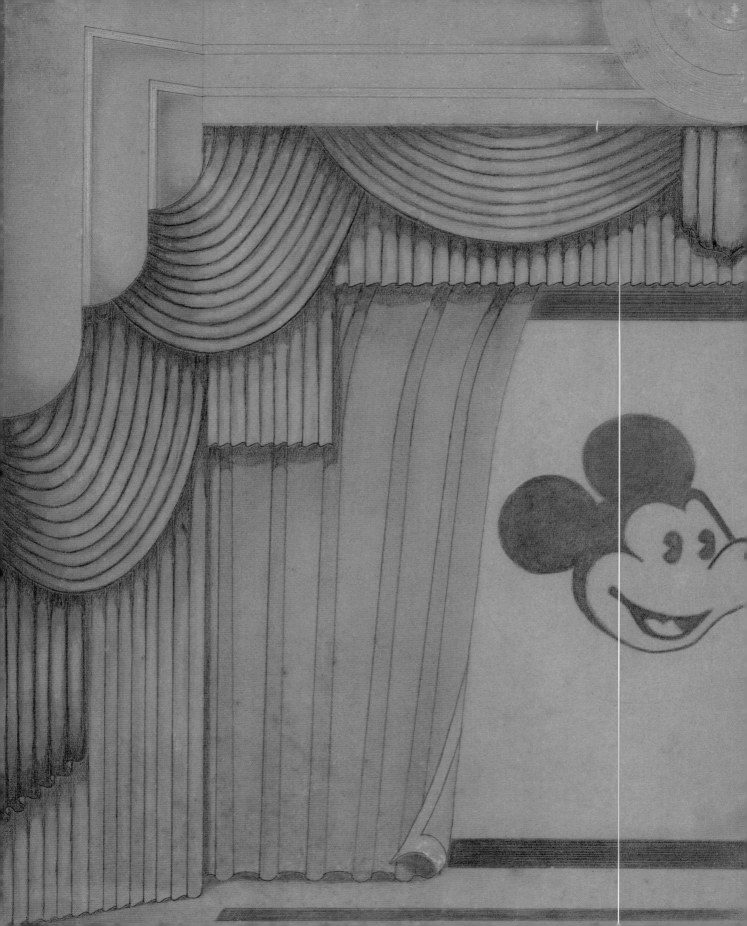

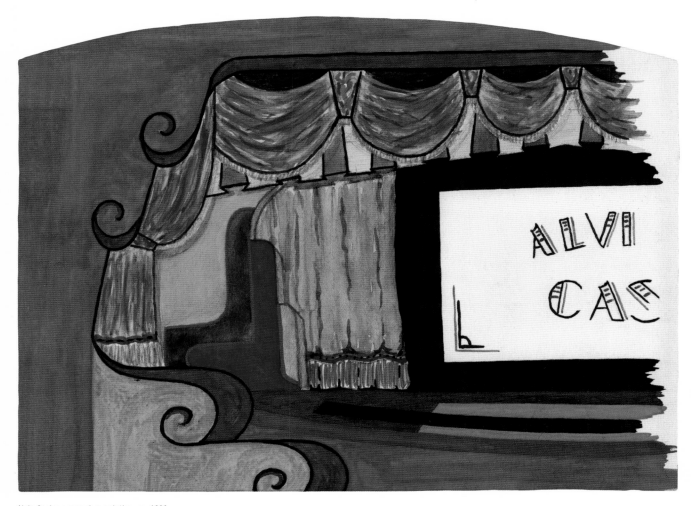

Alvin Casino proscenium painting, ca. 1939

opposite:

Mickey Mouse with proscenium drapes, ca. 1938

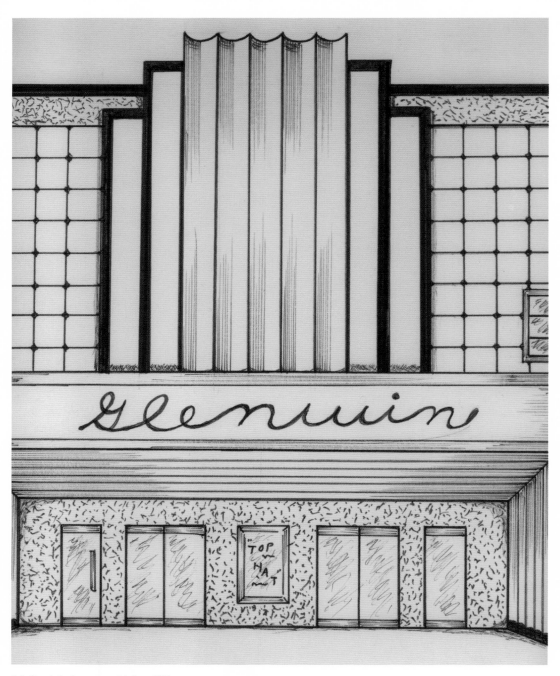

Alvin Glenwin Casino marquee detail, ca. 1952

opposite:

Alvin Glenwin Casino exterior door detail, ca. 1952

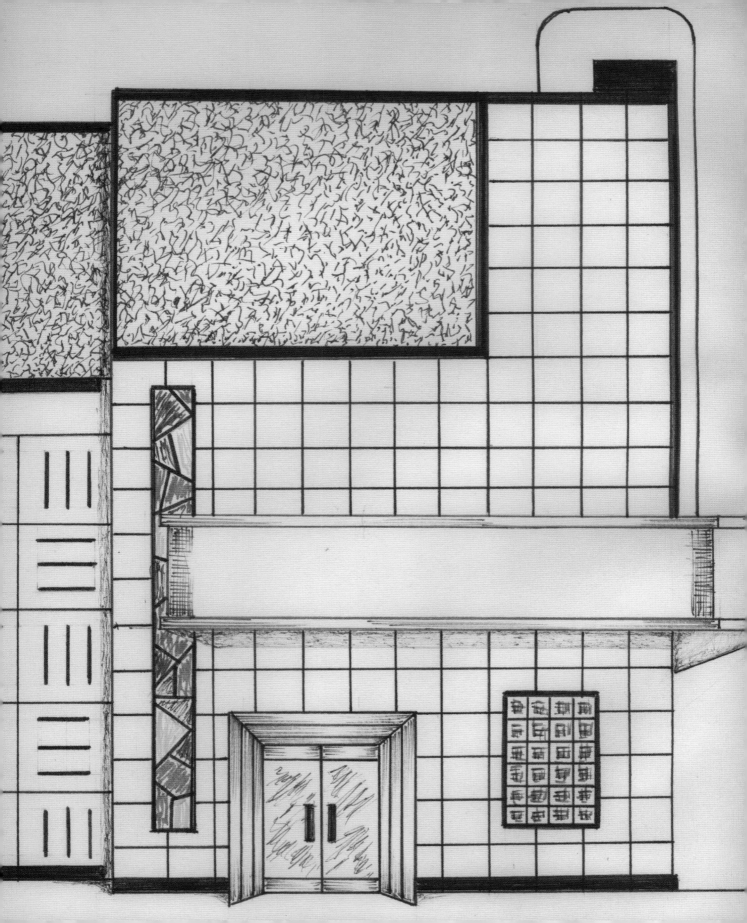

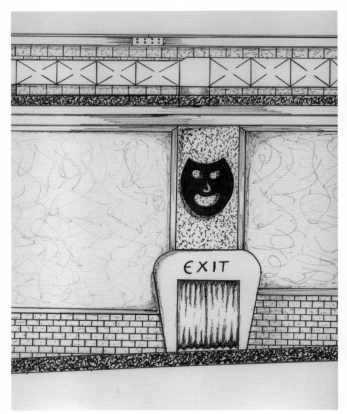

Alvin Glenwin Casino interior detail, ca. 1952

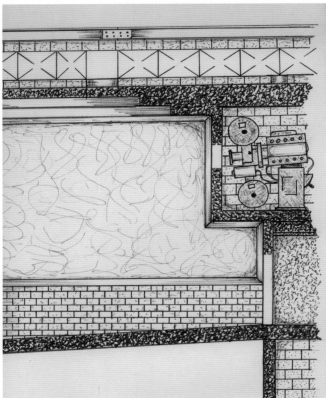

Alvin Glenwin Casino projector detail, ca. 1952

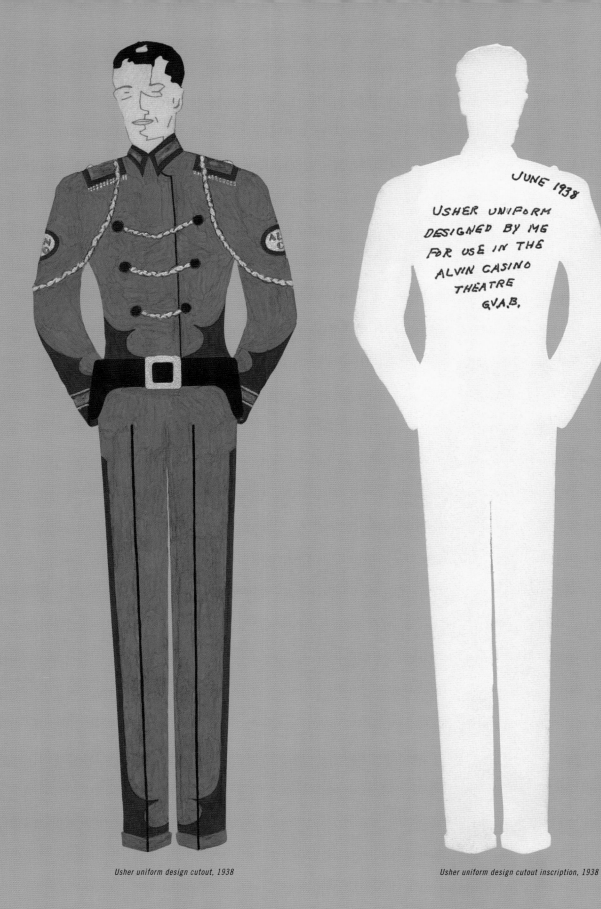

Usher uniform design cutout, 1938

Usher uniform design cutout inscription, 1938

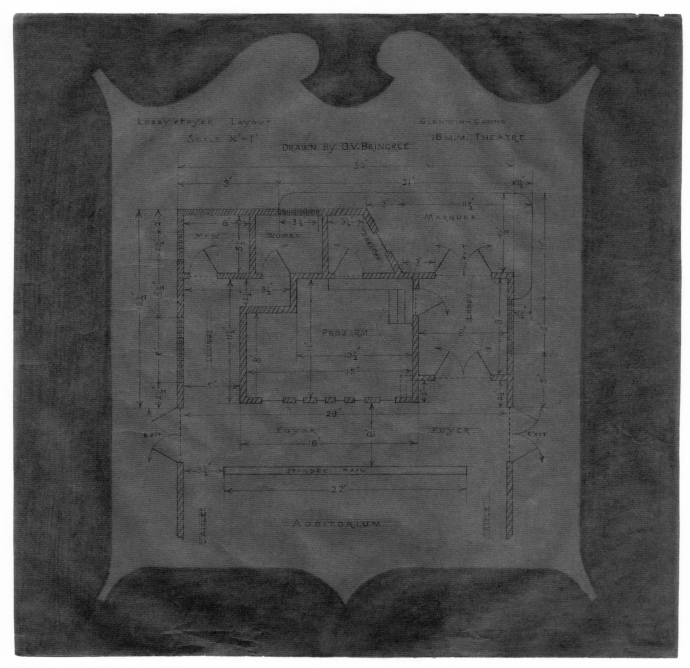

Glenwin Casino lobby and foyer layout, ca. 1947

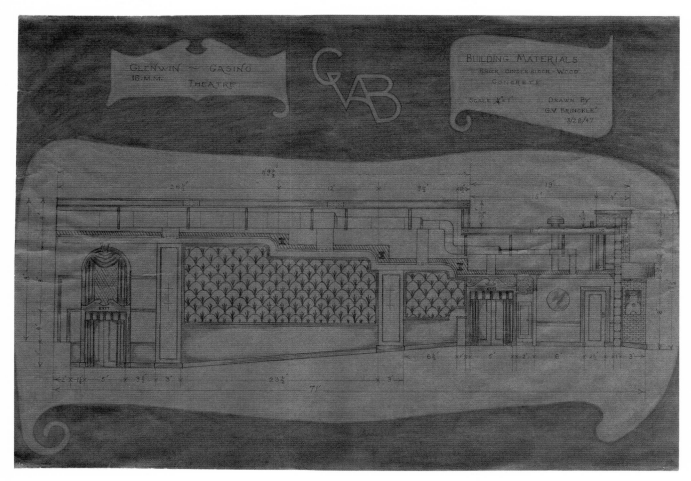

Glenwin Casino 16-mm Theatre, 1947

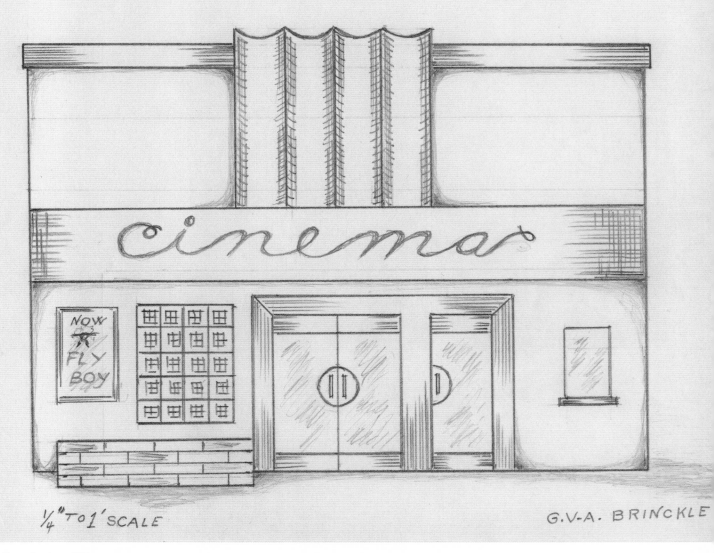

1/4" TO 1' SCALE

G.V.A. BRINCKLE

Cinema facade, ca. 1960

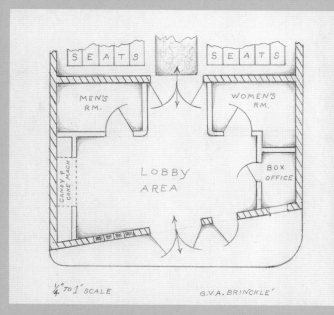

Cinema lobby, ca. 1960

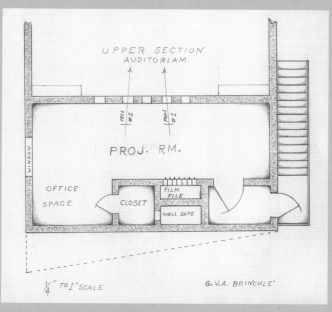

Cinema projection room, ca. 1960

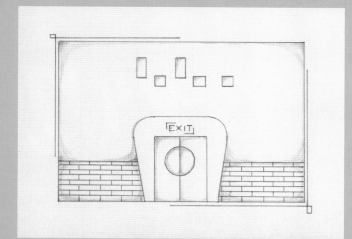

Cinema exit, ca. 1960

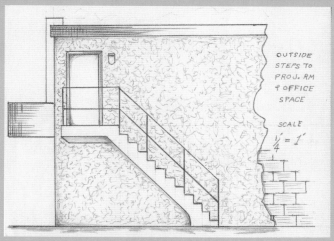

Cinema stairs, ca. 1960

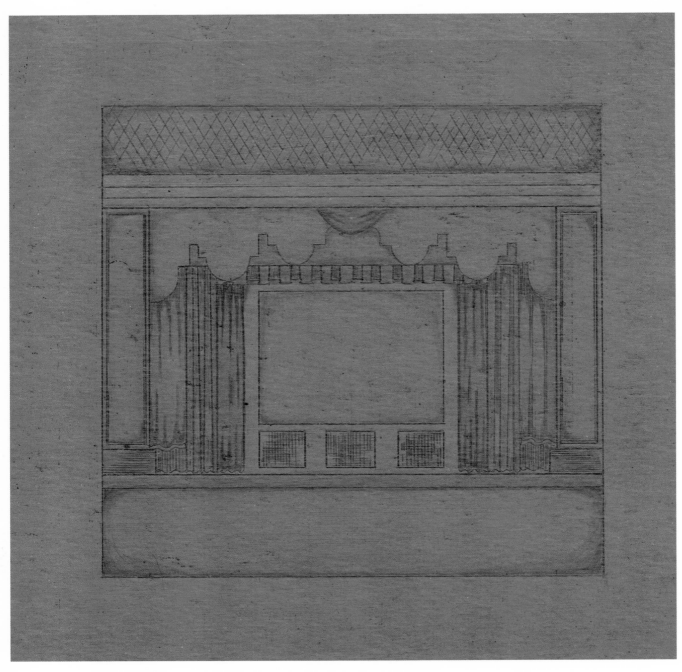

Proscenium with drapery treatment, ca. 1947

Linoleum block print of proscenium, ca. 1939

Linoleum block for proscenium, ca. 1939

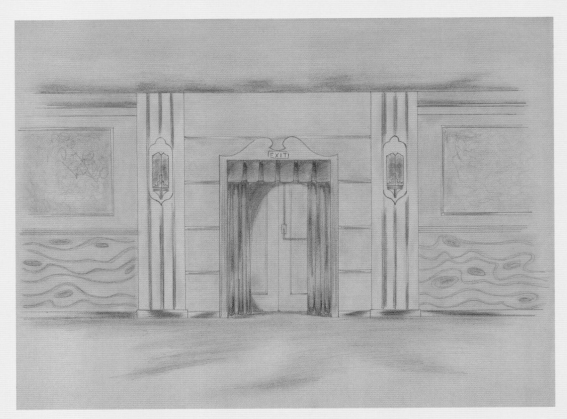

Polychromatica, lobby exit detail, ca. 1948

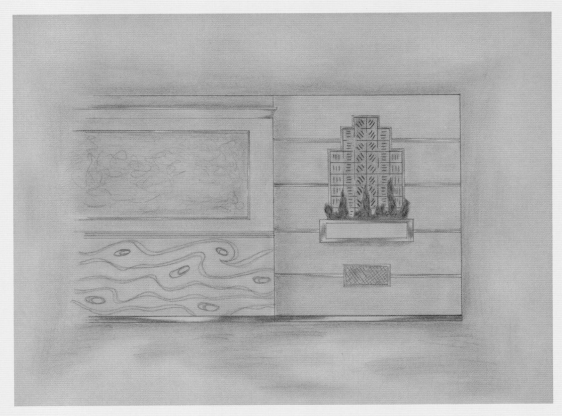

Polychromatica, lobby detail with glass block, ca. 1948

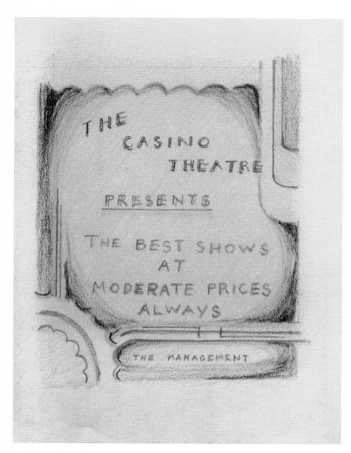

"The Best Shows at Moderate Prices," ca. 1938

overleaf:

Alvin Casino marquee, ca. 1947

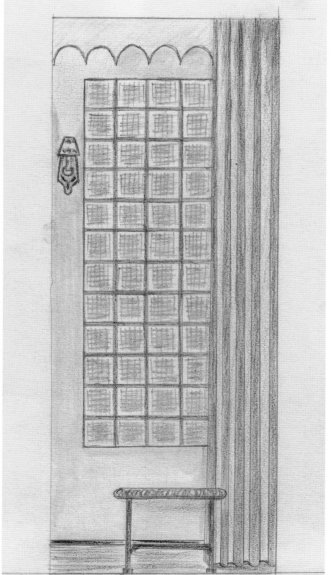

Polychromatica, interior detail, ca. 1938

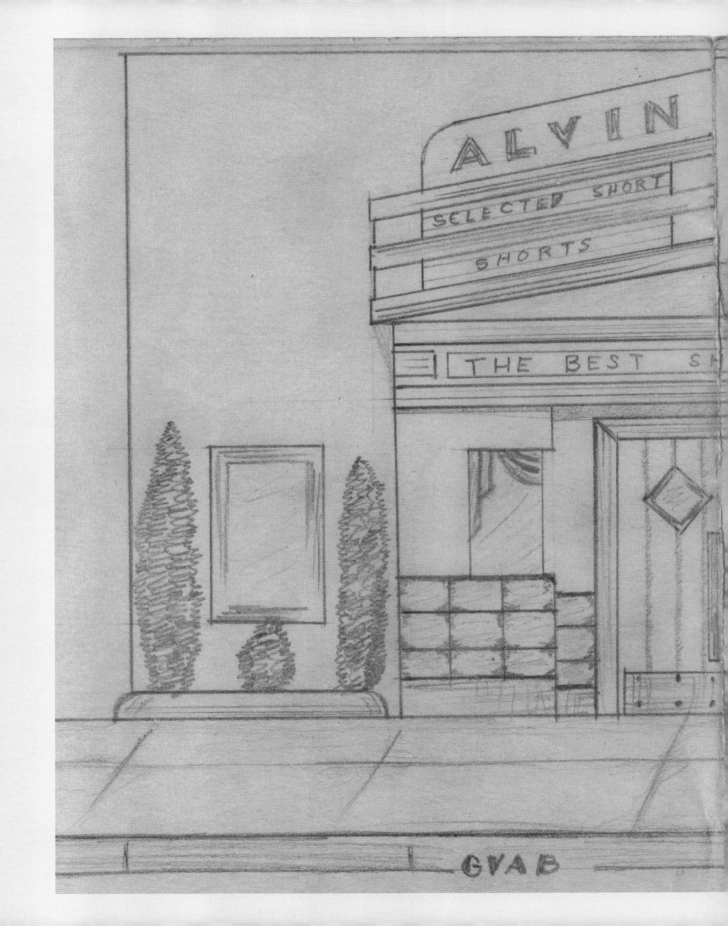

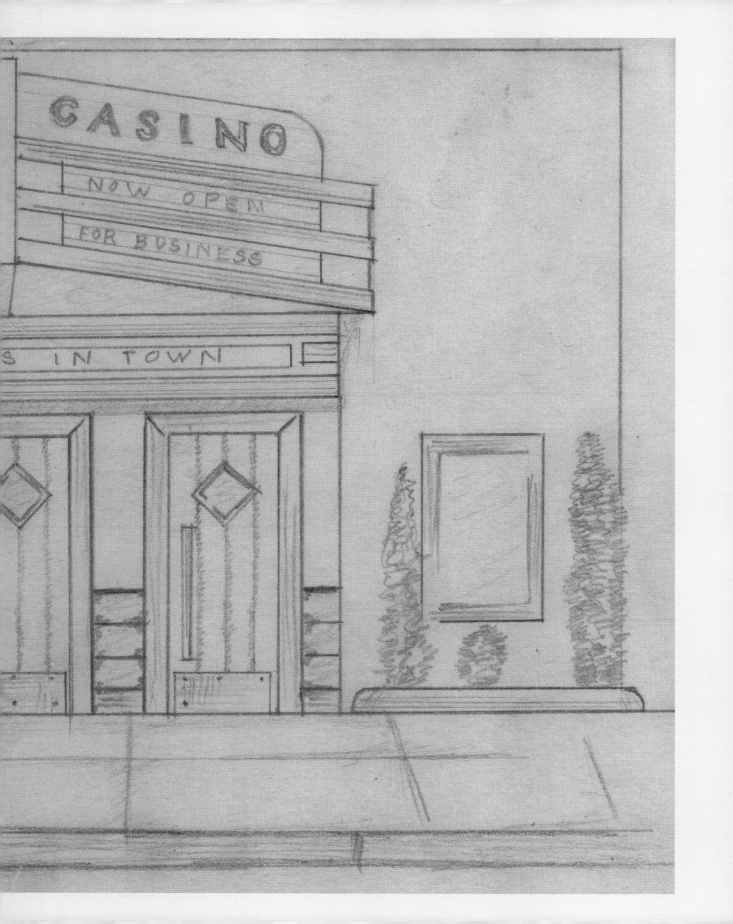

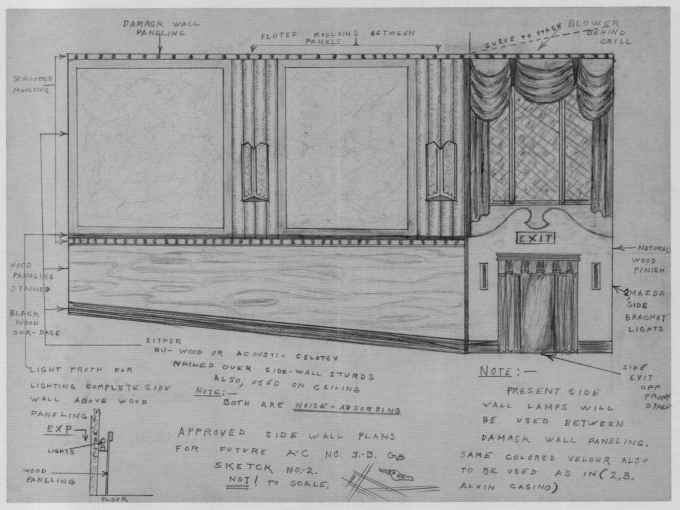

DAMASK WALL PANELING

FLUTED MOULDING BETWEEN PANELS

CURVE TO STAGE BLOWER BEHIND GRILL

SCOLLOPED MOULDING

WOOD PANELING STAINED

BLACK WOOD SUB-BASE

LIGHT TROTH FOR LIGHTING COMPLETE SIDE WALL ABOVE WOOD PANELING

EXP

LIGHTS

WOOD PANELING

FLOOR

EITHER NU-WOOD OR ACOUSTI-CELOTEX NAILED OVER SIDE-WALL STUDS ALSO, USED ON CEILING

Note:—
BOTH ARE NOISE-ABSORBING

APPROVED SIDE WALL PLANS FOR FUTURE A-C NO. 3-B. G.B SKETCH NO-2. NOT! TO SCALE.

EXIT

NATURAL WOOD FINISH

2 MAZDA SIDE BRACKET LIGHTS

SIDE EXIT OFF FROM STAGE

NOTE:—
PRESENT SIDE WALL LAMPS WILL BE USED BETWEEN DAMASK WALL PANELING. SAME COLORED VELOUR ALSO TO BE USED AS IN (2.B. ALVIN CASINO)

Sidewall drawing with specifications, ca. 1947

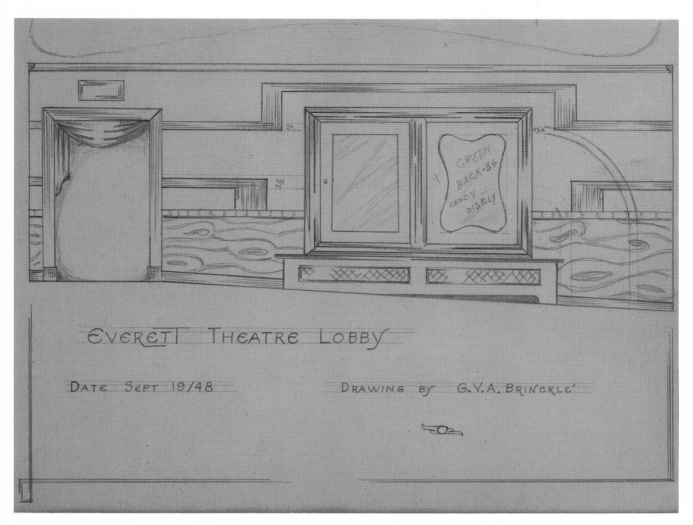

Everett Theatre lobby, 1948

American flag marquee, ca. 1947

GVAB monogram linoleum block, ca. 1936

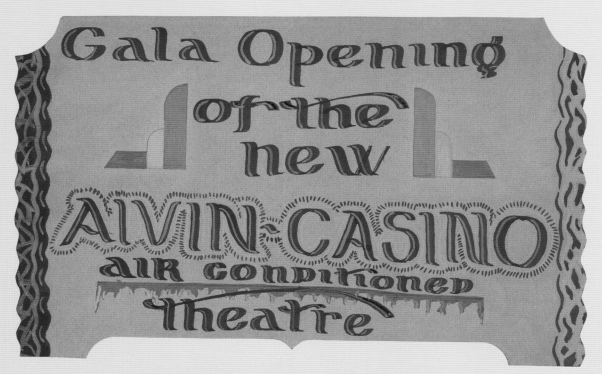

Gala Opening placard, ca. 1935

Linoleum block for Alvin Casino tickets, ca. 1935

Linoleum block print of Alvin Casino ticket, ca. 1935

overleaf:

Untitled collage (assembled by Kendall Messick), 2003

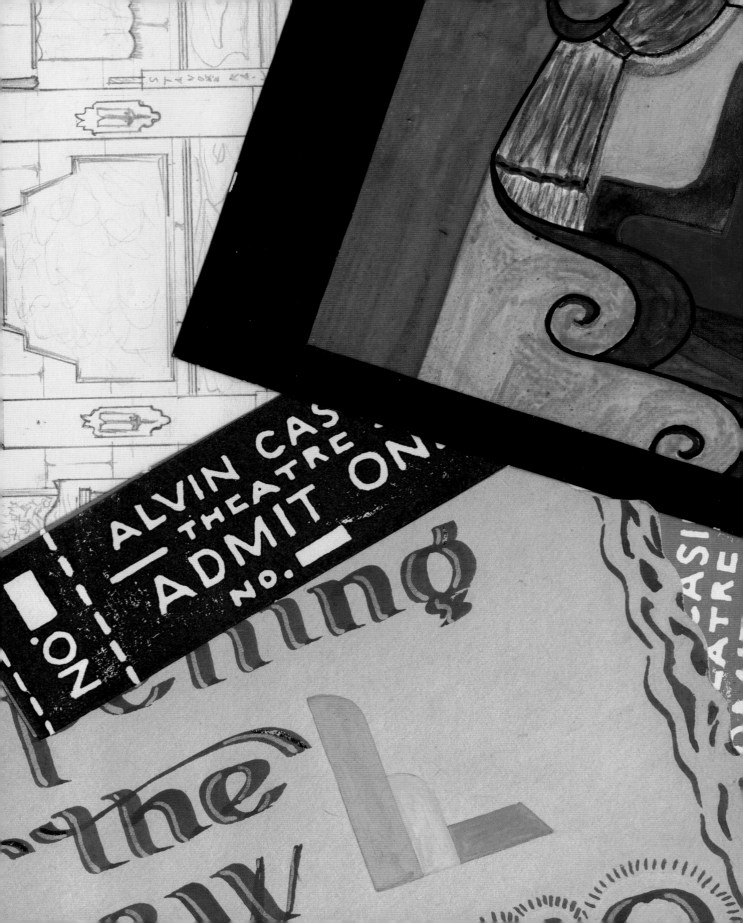

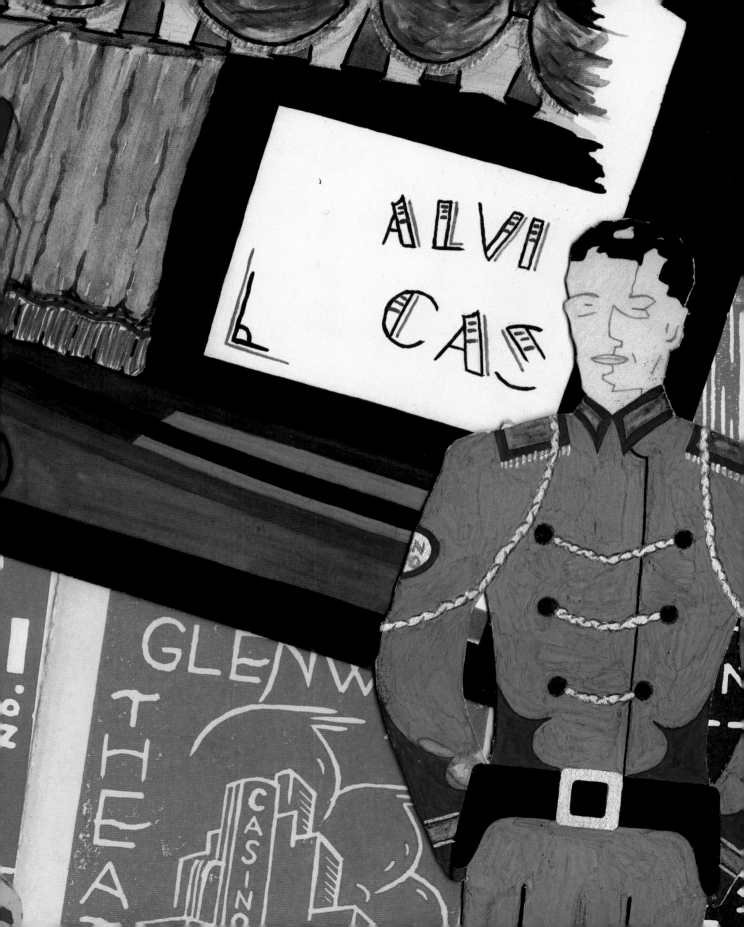

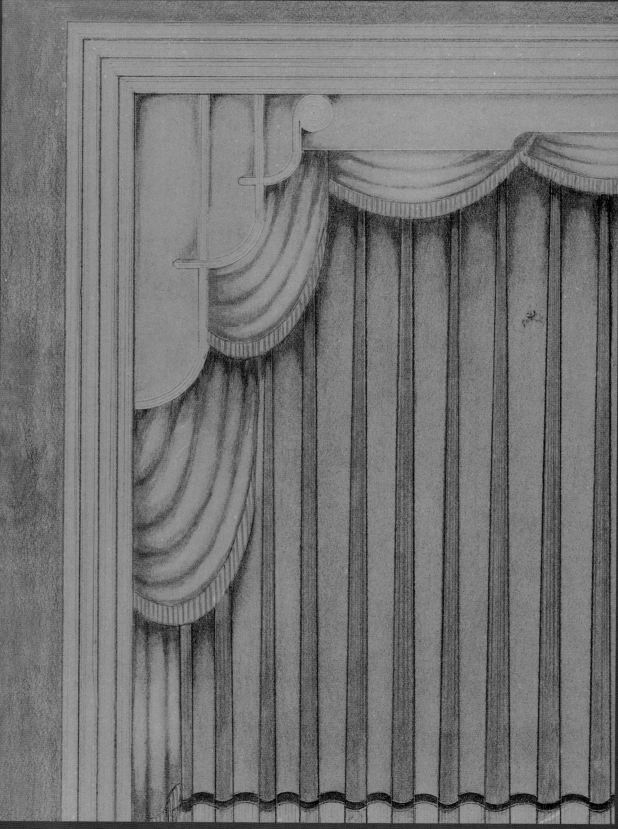

Drapery treatment, ca. 1938

Drapery sketch, ca. 1950

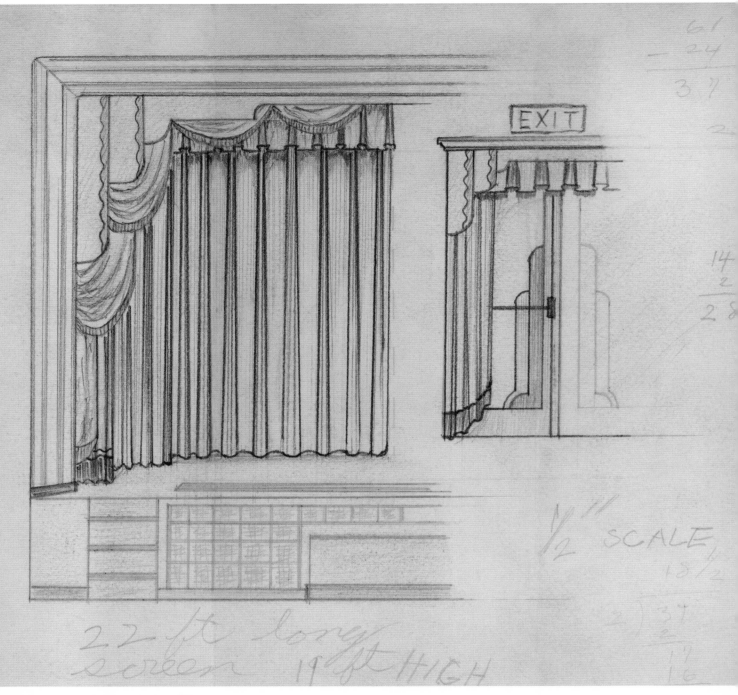

Proscenium and exit treatment sketch, ca. 1950

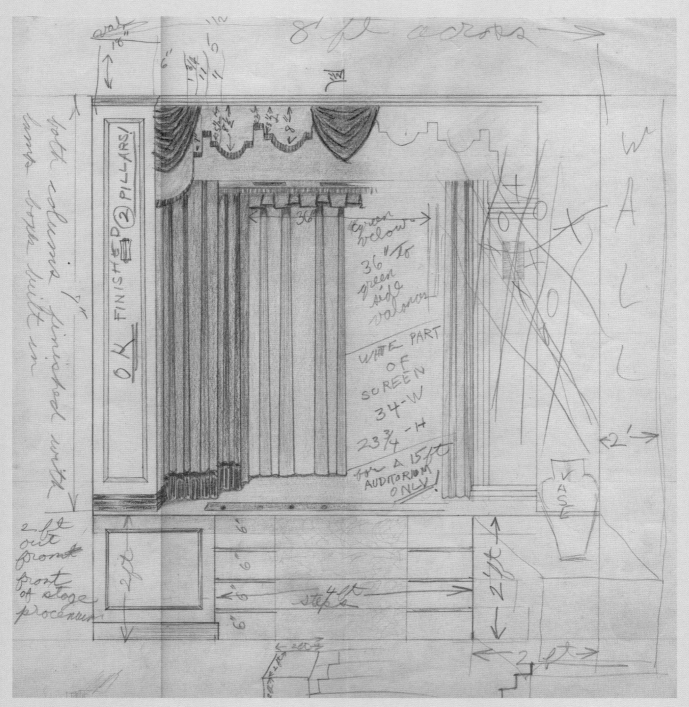

Sketch of drapes with notes, ca. 1950

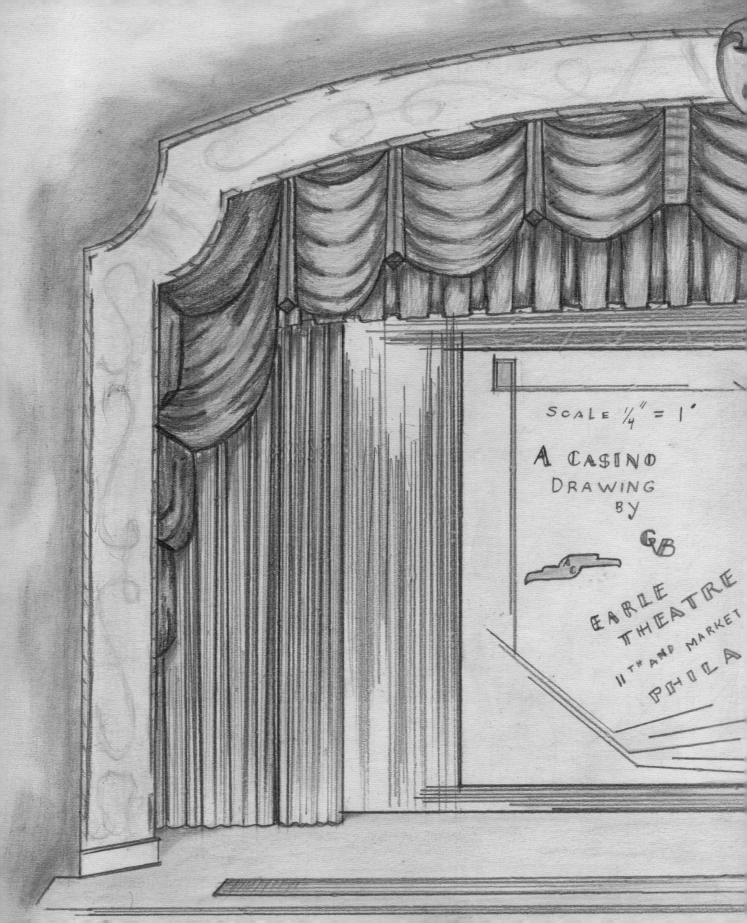

SCALE ¼" = 1'

A CASINO
DRAWING
BY

GB

EARLE
THEATRE
11ᵗʰ AND MARKET
PHILA

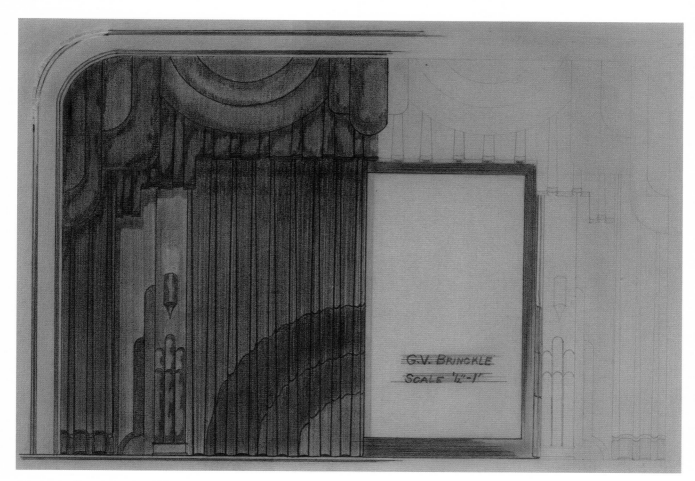

Full proscenium drapery treatment, ca. 1938

opposite:

Earl Theatre drawing, 1938

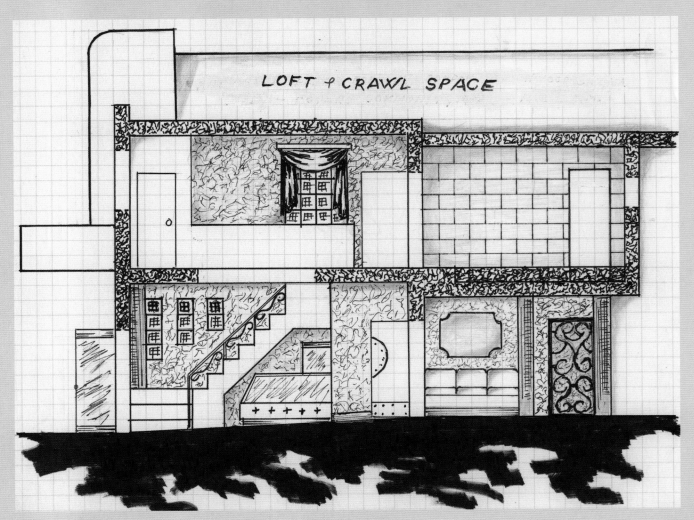

LOFT & CRAWL SPACE

Gordon Beechwood interior, ca. 1960

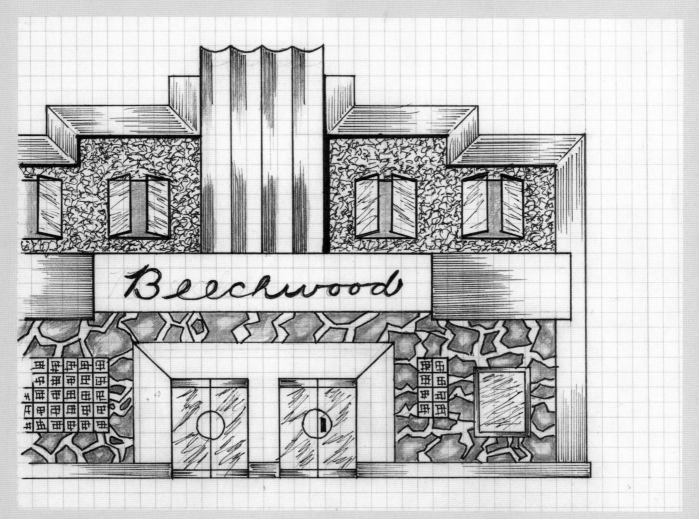

Gordon Beechwood marquee, ca. 1960

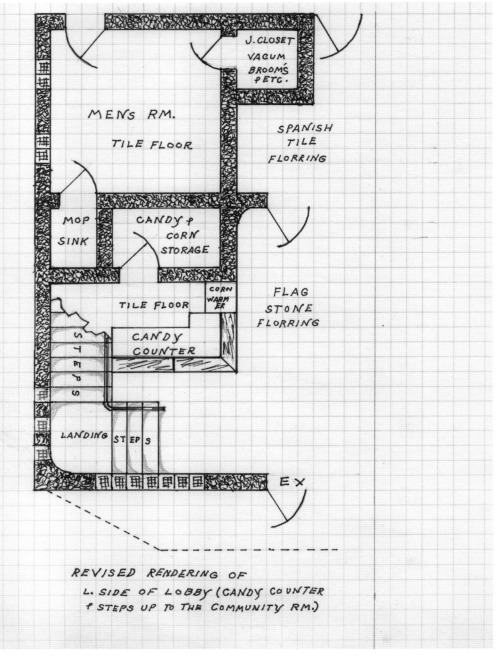

Gordon Beechwood revised lobby rendering (left side), ca. 1960

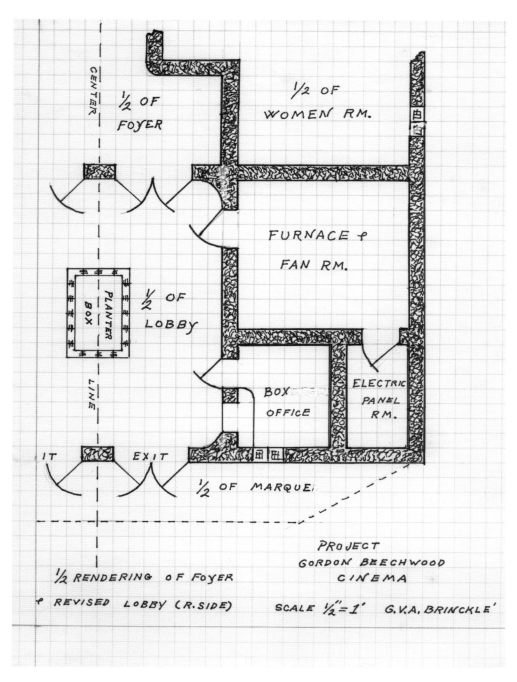

CENTER LINE

½ OF FOYER

½ OF WOMEN RM.

PLANTER BOX

½ OF LOBBY

FURNACE & FAN RM.

BOX OFFICE

ELECTRIC PANEL RM.

IT EXIT

½ OF MARQUEE

PROJECT
GORDON BEECHWOOD
CINEMA

½ RENDERING OF FOYER & REVISED LOBBY (R.SIDE)

SCALE ½"=1' G.V.A. BRINCKLE'

Gordon Beechwood revised lobby rendering (right side), ca. 1960

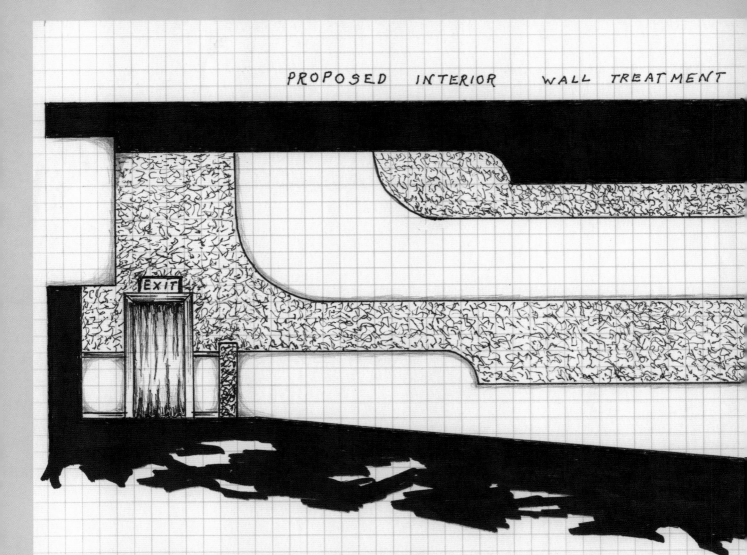

Gordon Beechwood wall treatment, ca. 1960

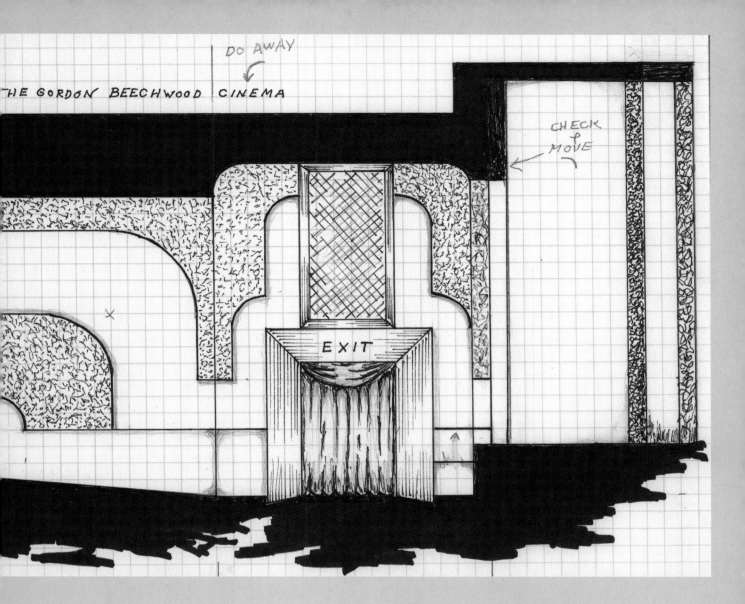

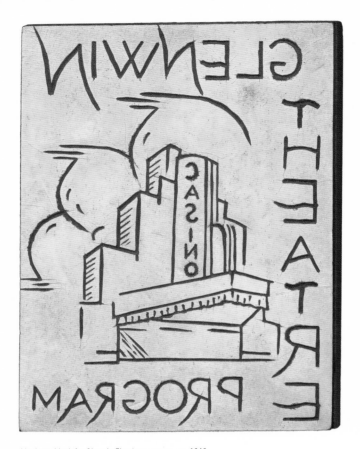

Linoleum block for Glenwin Theatre program, ca. 1942

opposite:

Linoleum block print of Glenwin Theatre program, ca. 1942

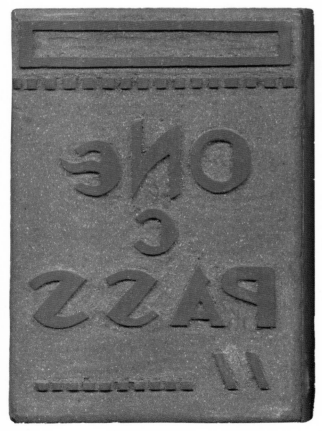

Linoleum block for complimentary pass, ca. 1935

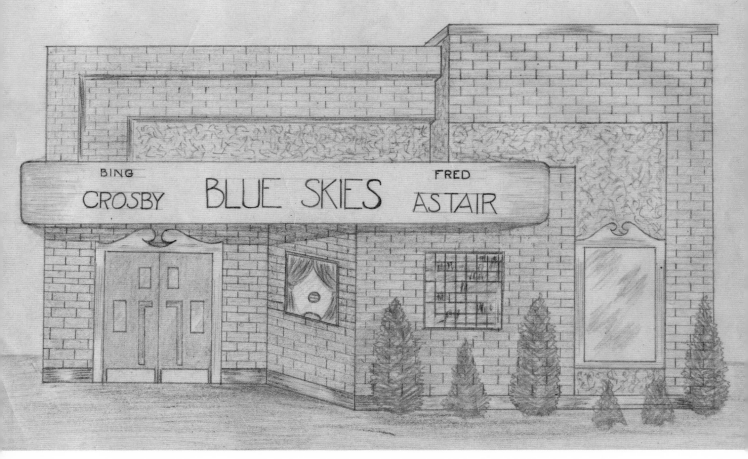

Blue Skies Theatre marquee, ca. 1946

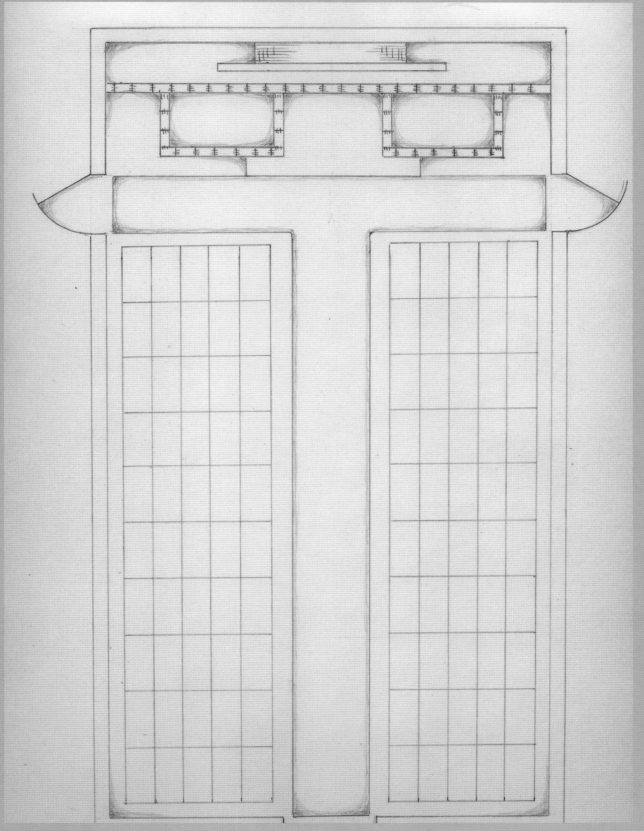

Plan of theater auditorium, ca. 1966

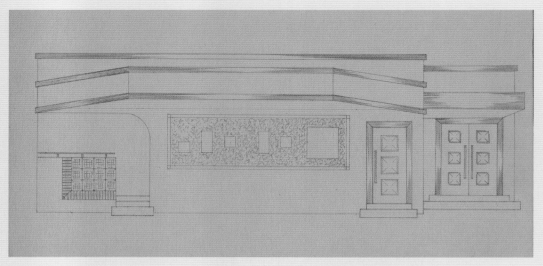

Rear wall view, ca. 1948

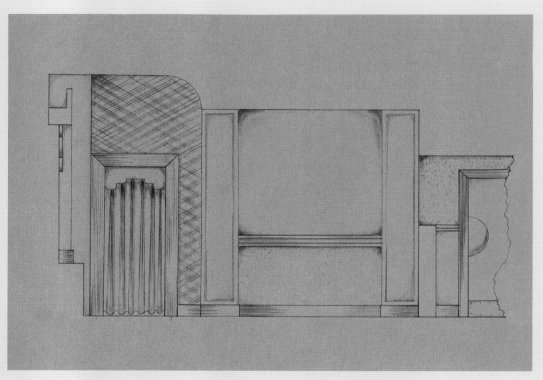

Side wall section view, ca. 1948

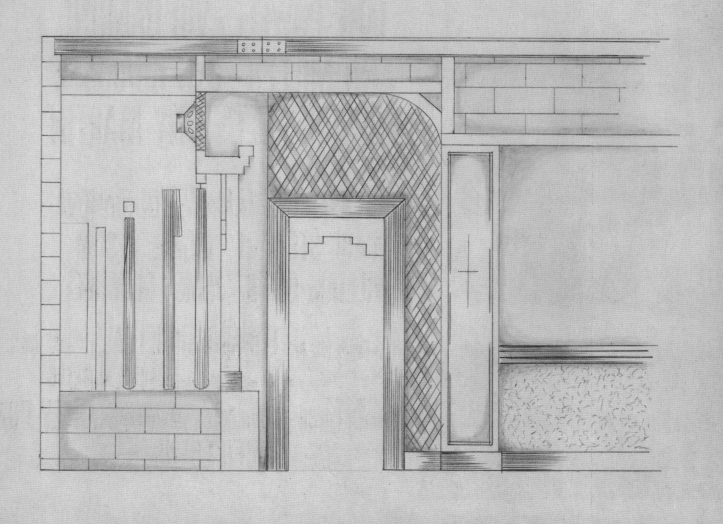

Side wall section view variation, ca. 1948

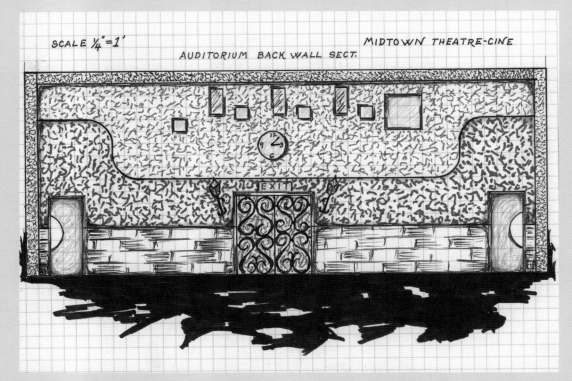

SCALE ¼"=1' MIDTOWN THEATRE-CINE

AUDITORIUM BACK WALL SECT.

Midtown Theatre-Cine back wall view, ca. 1970

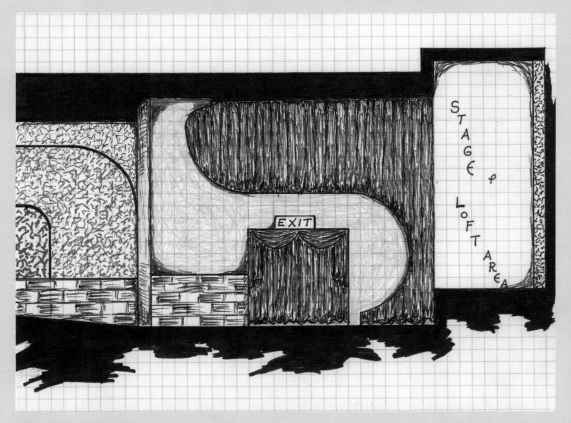

STAGE LOFT AREA

EXIT

Midtown Theatre-Cine interior sidewall, ca. 1970

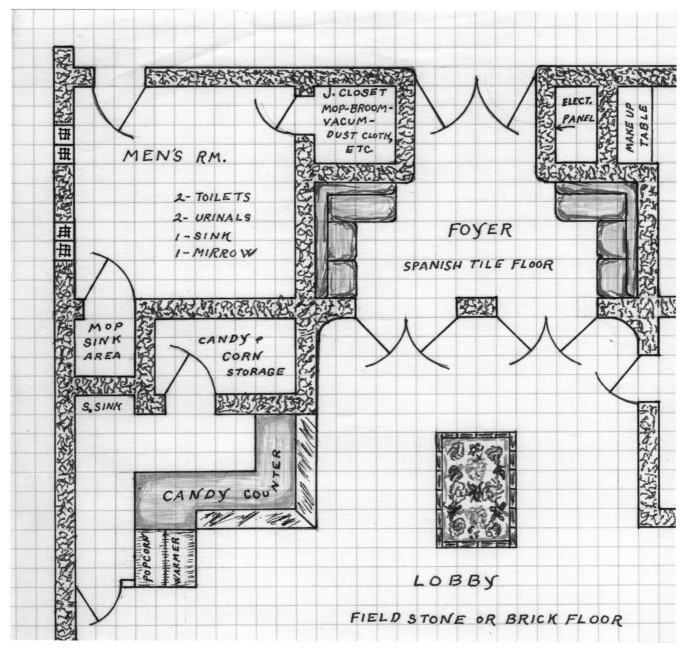

Midtown Theatre-Cine lobby layout, ca. 1970

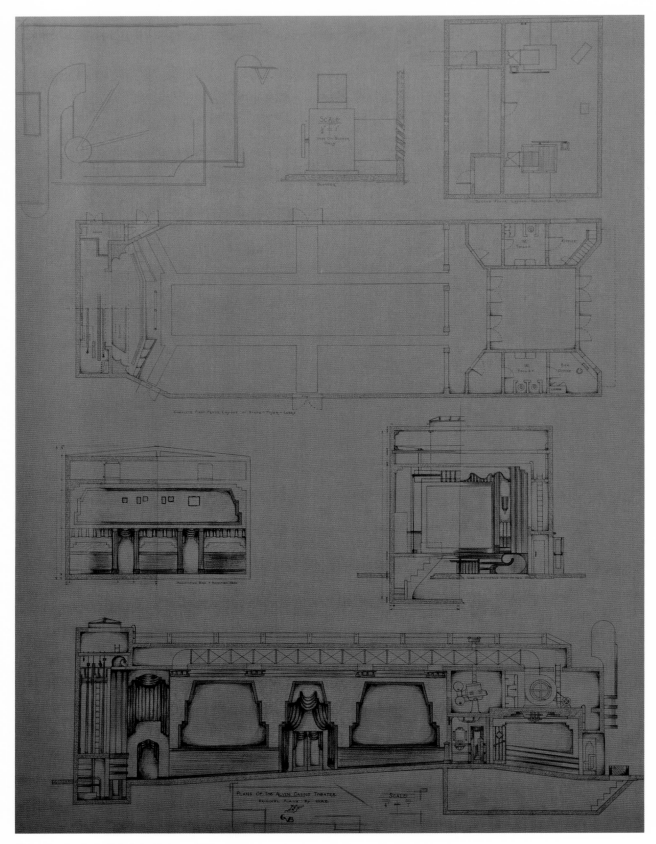

Plans and sections for the Alvin Casino Theatre, ca. 1933

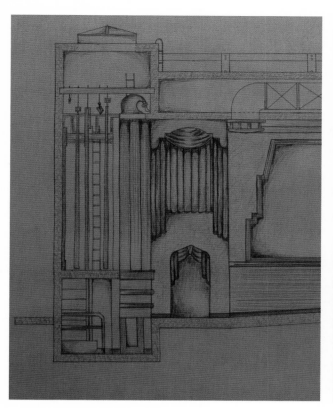

Alvin Casino Theatre section detail, ca. 1933

Alvin Casino Theatre section detail, ca. 1933

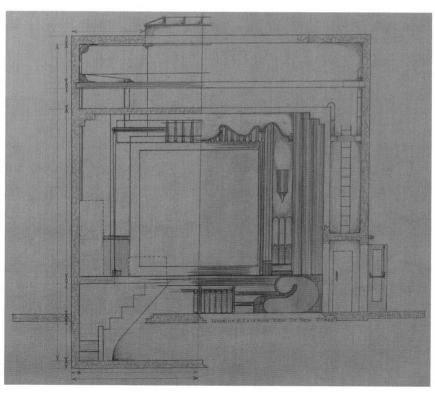

Alvin Casino Theatre section detail, ca. 1933

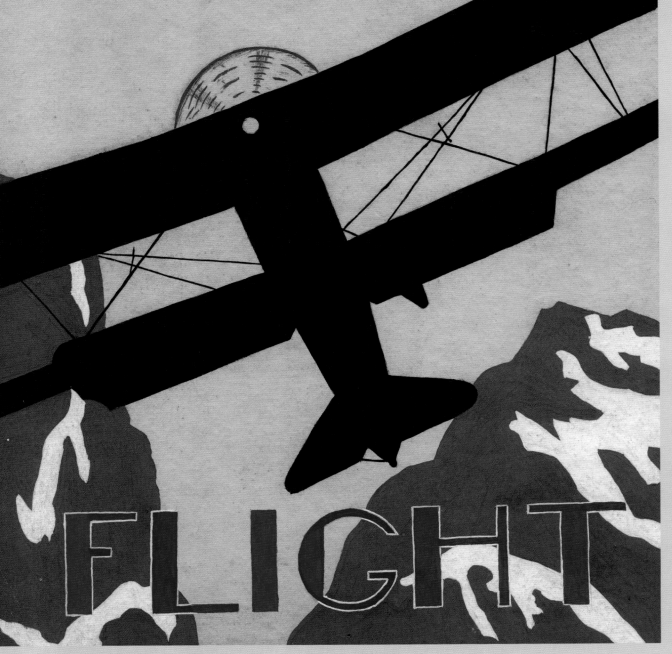

Night Flight *book cover design, ca. 1932*

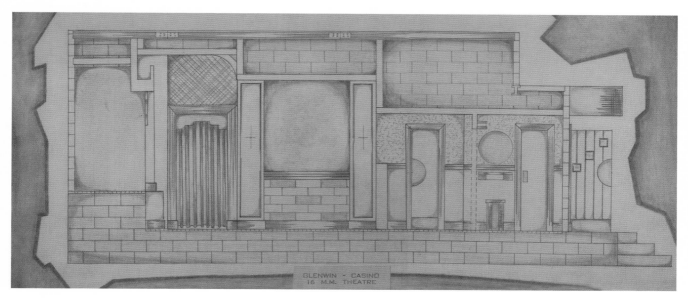

Glenwin Casino 16-mm Theatre, ca. 1960

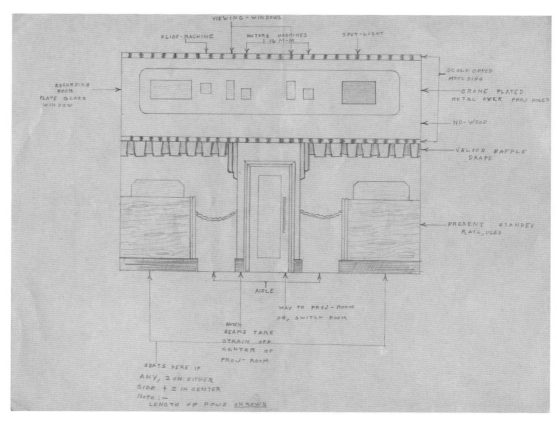

Rear wall drawing, ca. 1960

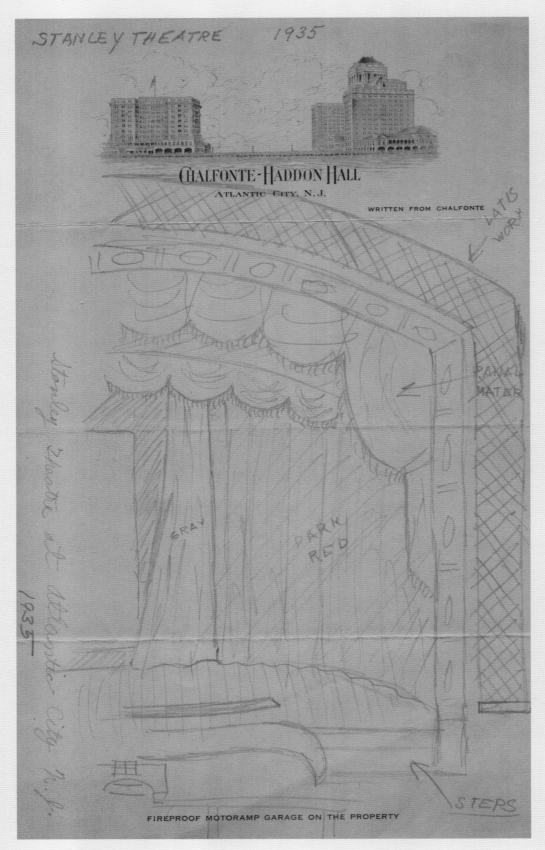

Stanley Theatre sketch, 1935

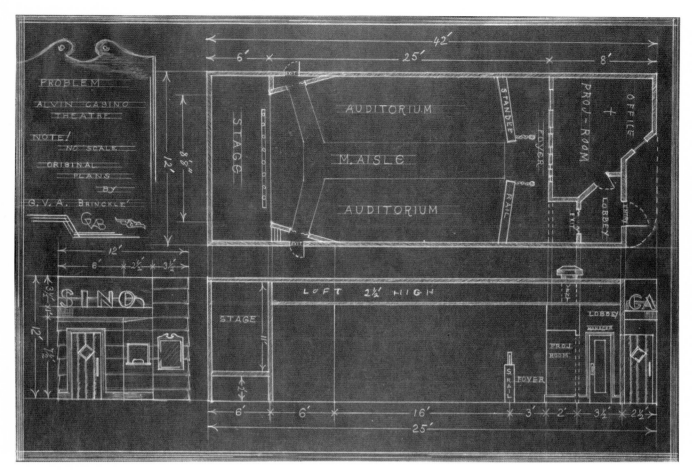

Alvin Casino Theatre Problem, ca. 1940

DESIGN MOTIFS

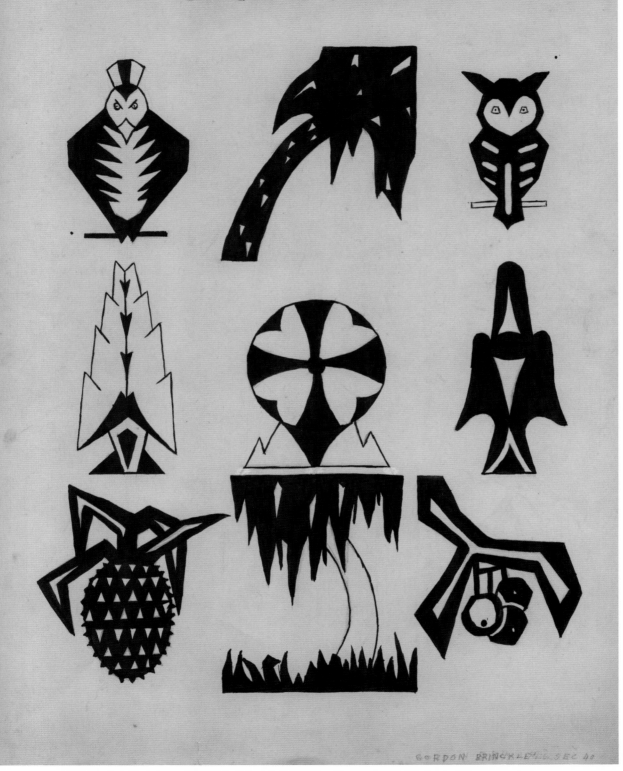

Design motifs, ca. 1932

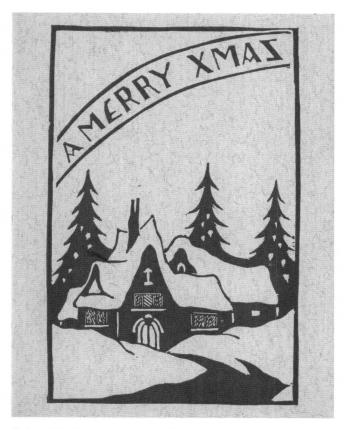

Linoleum block prints for Christmas cards, 1935

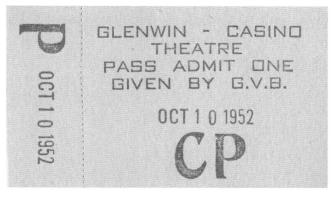
Glenwin Casino Theatre pass, 1952

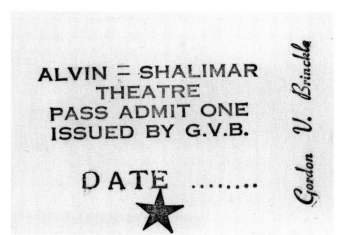
Alvin Shalimar Theatre pass, ca. 1965

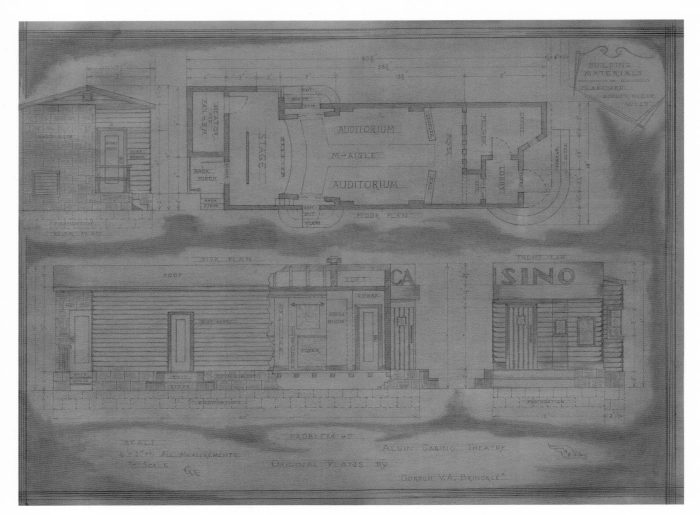

Alvin Casino Theatre Problem #2, ca. 1948

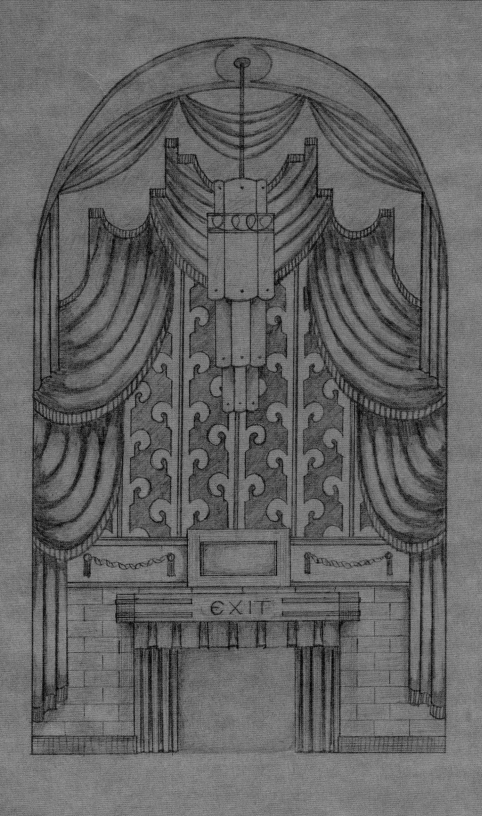

Exit treatment, ca. 1941

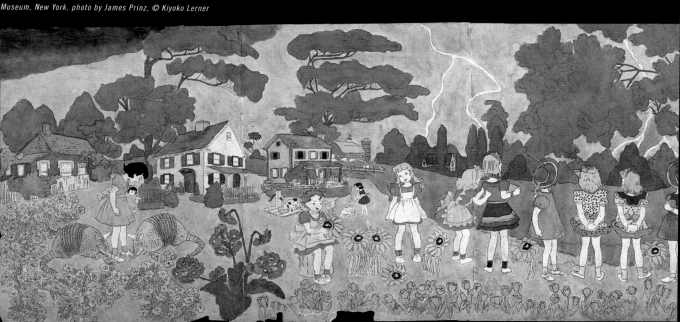

CINEMA AND THE AUTODIDACT

Brooke Davis Anderson

It has long been thought that artists who work on the perimeter of the mainstream art discourse, like Gordon Brinckle, create artwork that does not connect to the culture of their time. Denying the visual literacy of artists who are self-taught, or those with little formal art training, has led to severe misinterpretations of their work. Only recently have scholars started to examine how *art brut* artists have always looked to popular media sources for artistic inspiration. For example, Adolf Wölfli (1864–1930), the grandfather of *art brut*, incorporated collage into his remarkable works on paper, pointing to his embrace of global culture. Treating collage as a tool for learning about form, color, perspective, and other formal aspects of art making, Wölfli and other visionary artists adopt the strategies seen in popular media. Magazines, newspapers, comic books, coloring books, and other everyday sources became the classroom, as it were.

While popular printed materials are gaining recognition in the research on self-taught artists and their work, the rise and expanding influence of film on twentieth-century vernacular voices has not yet been examined. Gordon

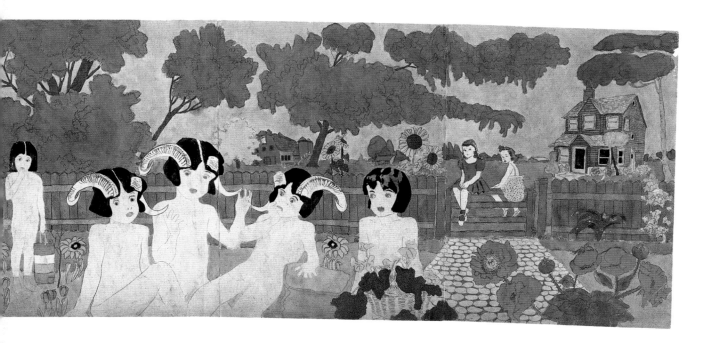

Brinckle's remarkable basement installation, the Shalimar Theatre, clearly shows that movie culture needs to be considered an important influence on at least some of the visionary artists who work on the fringes of the high art establishment. Brinckle's whole life was marked by his passion for the moving image, and his many drawings, linoleum prints, plans, and collages, as well as his basement theater, focus on the cinema. The era of grand movie palaces became the main impulse for his creative output. Two well-known self-taught artists, Henry Darger (1892–1973) and Martín Ramírez (1895–1963), also evoke the cinema in their artwork, allowing us to explore the possible pervasive influence of film, movie palaces, and Hollywood culture in the vernacular art world.

The extensive Henry Darger Study Center, housed at the American Folk Art Museum, contains more than five thousand archival objects, including clippings from magazines, newspapers, coloring books, and cartoons, demonstrating how Darger imprinted his artwork with popular culture. Sifting through these extensive records, one longs to find a movie ticket stub in the mounds of paperwork.[1]

Such a find might explain the cinematic scope Darger used to illustrate his epic tale, *The Story of the Vivian Girls, in what is Known as the Realms of the Unreal, of the Glandeco-Angelinnian War Storm, Caused by the Child Slave Rebellion*. No other artist has illustrated a manuscript with paintings of such large scale—three feet high and ten to twelve feet long—handily adopting the horizontal frame of a movie screen. No other war story is accompanied by similarly grand live-action battle scenes as realized in the startling watercolor collages by Darger. Could his experience in a movie palace have urged on these unpredictable, massive-sized artworks?

The ephemera preserved in the Henry Darger Study Center includes a few illustrations from periodicals showing a panoramic approach to depicting battle scenes, and these surely were primary resources for the artist, but they do not explain the monumental scale of his three hundred watercolor paintings. Darger came of age in the golden era of cinema, and we know that he was a huge fan of L. Frank Baum's series of books, *Oz*. We cannot help but wonder

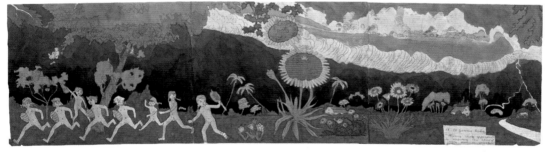

Henry Darger, 53 At Jennie Richee Assuming nuded appearance by compulsion race ahead of coming storm to warn their father
Watercolor, pencil, and carbon tracing on pieced paper, 19 x 70 ¼ inches
Gift of Ralph Esmerian in memory of Robert Bishop, 2000.25.3A , collection American Folk Art Museum, New York, photo by James Prinz, © Kiyoko Lerner

The Untold Stories of the Civil War, Part II: The Braves in Blue and Gray,
Clipping from the Saturday Evening Post, *January 14, 1961, 13 ½ x 20 ¾ inches*
Collection American Folk Art Museum, New York, gift of Kiyoko Lerner,
photo by Gavin Ashworth, New York

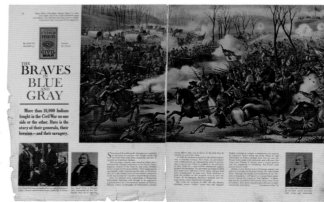

whether the artist saw the film *Wizard of Oz*, when it was released in 1939. It was around this time that Darger's watercolor paintings grew in scale, and each of his scroll-length paintings could be compared to one frame in a movie. While no movie ticket stubs exist confirming the possibility, the artist's inventive scale and playful compositional devices (and even his frisky, Disney-inspired birds) point to an appreciation for the medium and a cinematic way of looking at things.[2]

While we may never know whether Darger was a moviegoer, we do know that film culture stepped right into Ramírez's path. When Ramírez was institutionalized at DeWitt State Hospital from 1948 to 1963, there was a fully functioning cinema on its campus, and the hospital organized Friday night movie screenings.[3]

Ramírez's works on paper, ripe with melancholy and nostalgia, frequently depict scenes on an ornate stage. Filtering cinematic experiences into his line-infused artwork, the artist shows horse riders, Madonnas, and the animal kingdom standing inside a movie palace setting, complete with stage, curtains, and footlights. In some cases, amongst the drawn drapes and valances, an audience is also remembered near and below the proscenium. Ramírez relied on this dynamic compositional device in more than one hundred drawings (nearly 25 percent of his entire oeuvre). This technique and its figures become scaffolding for the finished work, while his subject matter emulates the concurrent Hollywood iconography, his horse and rider bringing to mind the western film genre so popular in Ramírez's time. And just as Darger's birds recall the cartoon creatures of Walt Disney Studios animated films, so too do occasional renderings of deer by the Mexican artist bring to mind the classic 1942 film, *Bambi*.

Gordon Brinckle shares several traits with Darger, Ramírez, and other self-taught artists, even though he did receive some vocational training in design and draftsmanship: like Darger and Ramírez, he had an all-encompassing passion for self-expression, an admirable commitment to art making, a sense of self-value leading to creative production, and an open-minded attitude and adventurous mindset. Like them, Brinckle valued the principle of "making do,"

Martín Ramírez, Untitled (Horse and Rider), *Auburn, California, ca. 1948–63*
Crayon and pencil on pieced paper, 33 ¾ x 23 ½ inches
Collection of Jan Petry, photo by William H. Bengtson, Chicago, © estate of Martín Ramírez

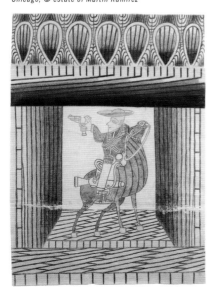

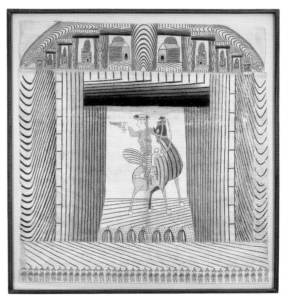

Martín Ramírez, Untitled (Horse and Rider), *Auburn, California, 1954*
Crayon and pencil on pieced paper, 49 x 44 ½ inches
Collection of L & L Feiwel, photo by Joseph Painter, courtesy of Fleisher/ Ollman Gallery, Philadelphia, © estate of Martín Ramírez

using humble and available material for his unconventional life's work, the Shalimar Theatre, rather than buying art supplies from an art store. All three artists herald from working class culture—the culture of the every man, the every day. They learned about formal art making qualities from the visual stimulus of their environment rather than instructional art manuals, and they worked hard, often for a lifetime and very frequently at great sacrifice of other things (family, friends, and careers, for example).

Brinckle illustrates an indisputable connection to contemporary culture as a movie-obsessed autodidact. Spunky, passionate, and tenacious, he often said he was "born into show business" and that he had "worked in the movie business in one way or another since 1936."[4] His lifetime commitment to his own basement creations, first the Alvin Casino and then the Shalimar, echoes Darger's dedication to his 15,000-page novel, *In the Realms of the Unreal*, on which the artist worked for more than half of his life. The Shalimar Theatre is an astounding work of art. Its quirky spirit attests to the obsessive nature of its maker. Its startling and garish colors, riotous patterning and textures, and astonishing forms and materials indicate an awesome devotion to art making, as well as to a pleasurable movie experience, whetting our appetite for cinema of an earlier era.

Masters of vernacular art such as Darger and Ramírez also propose a provocative link between visionary artists of the twentieth century and cinema culture. The site of the theater, the stage, and its decorative attributes, have preoccupied many self-taught artists of our time, such as Morris Hirshfield (1872–1946) and

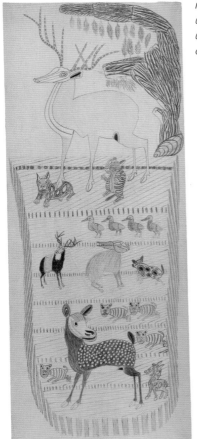

Martín Ramírez, Untitled (Animal Scroll), *Auburn, California, ca. 1950*
Crayon and pencil on paper, 59 ½ x 24 inches
Collection of Phyllis Kind Gallery, New York, photo by Phyllis Kind Gallery,
© estate of Martín Ramírez

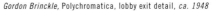

Gordon Brinckle, Polychromatica, lobby exit detail, *ca. 1948*

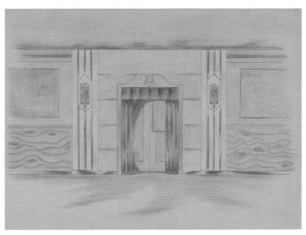

Lee Godie (1908–1994), to name a few. Picking apart their ties to popular culture—Wölfli and magazines, Darger and coloring books, Ramírez and Hollywood films, and Gordon Brinckle and movie palaces—places these artists squarely in the center of an everyday mainstream. Other than often thought, they are not isolated, not reclusive, to any place but the world of high art. They show us that extraordinary things happen in the popular and "low" places sometimes overlooked, and that masterful works of art are not the sole domain of the art establishment.

Brinckle playfully and inventively recreated a movie house in three dimensions, solidifying his vivid admiration for the cinema and all that it promised to an early twentieth-century American audience. His Shalimar Theatre is an audacious concept and exemplifies the bold singularity of many contemporary self-taught creators: not hemmed in by the strictures of the art academy, they resolutely follow their individual visions. The Shalimar declares Brinckle as a man who had the dream of a Hollywood player and the soul of an artist: an envious combination of traits that allowed him the freedom to conceive and build "the last authentic movie palace in Delaware."

1. While a large quantity of material was preserved by Nathan and Kiyoko Lerner (all now in the collection of the American Folk Art Museum in New York and Intuit in Chicago), a lot of items from Darger's apartment was thrown away before the discovery of his artwork. It is possible that movie ticket stubs were thrown away.

2. More on recent scholarship on Henry Darger can be found in the essay, Brooke Davis Anderson, "An Artist's Studio at 851 Webster Avenue," in Klaus Biesenbach, *Henry Darger* (New York: Prestel, 2009).

3. Conversations between the author and staff members from 2006 to the present about the functioning cinema on the hospital campus.

4. Quoted from the documentary film, *The Projectionist*.

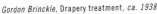

Gordon Brinckle, Drapery treatment, *ca. 1938*

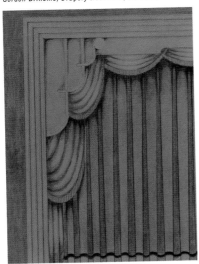

Gordon Brinckle, Proscenium with organ, *ca. 1940*

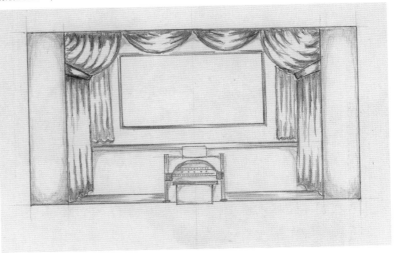

PUBLISHED BY

Princeton Architectural Press

37 East Seventh Street

New York, New York 10003

For a free catalog of books, call 1.800.722.6657.

Visit our web site at www.papress.com.

© 2010 Princeton Architectural Press

All rights reserved

Printed and bound in China

13 12 11 10 4 3 2 1 First edition

EDITOR

Nicola Bednarek

DESIGNER

Jan Haux

SPECIAL THANKS TO

Nettie Aljian, Bree Anne Apperley, Sara Bader,
Janet Behning, Becca Casbon, Carina Cha,
Tom Cho, Penny (Yuen Pik) Chu, Carolyn Deuschle,
Russell Fernandez, Pete Fitzpatrick,
Linda Lee, Laurie Manfra, John Myers,
Katharine Myers, Steve Royal,
Dan Simon, Andrew Stepanian, Jennifer Thompson,
Paul Wagner, Joseph Weston, Deb Wood
of
Princeton Architectural Press
—Kevin C. Lippert, publisher

Library of Congress Cataloging-in-Publication Data

Messick, Kendall, 1965–

The projectionist / Kendall Messick. — 1st ed.

p. cm.

Documents Brinckle's life and a 2006 traveling exhibition which showcased
his custom built theater with the actual structure, videos, and photographs.

ISBN 978-1-56898-933-4 (alk. paper)

1. Brinckle, Gordon, 1915–2007. 2. Motion picture projectionists—United
States—Biography. 3. Motion picture theaters—Delaware—Middletown—
Pictorial works. 4. Theater architecture. 5. Performance art. 6. Messick,
Kendall, 1965– I. Title.

TR849.B75M47 2010

778.5'5092—dc22

[B]

2010008864

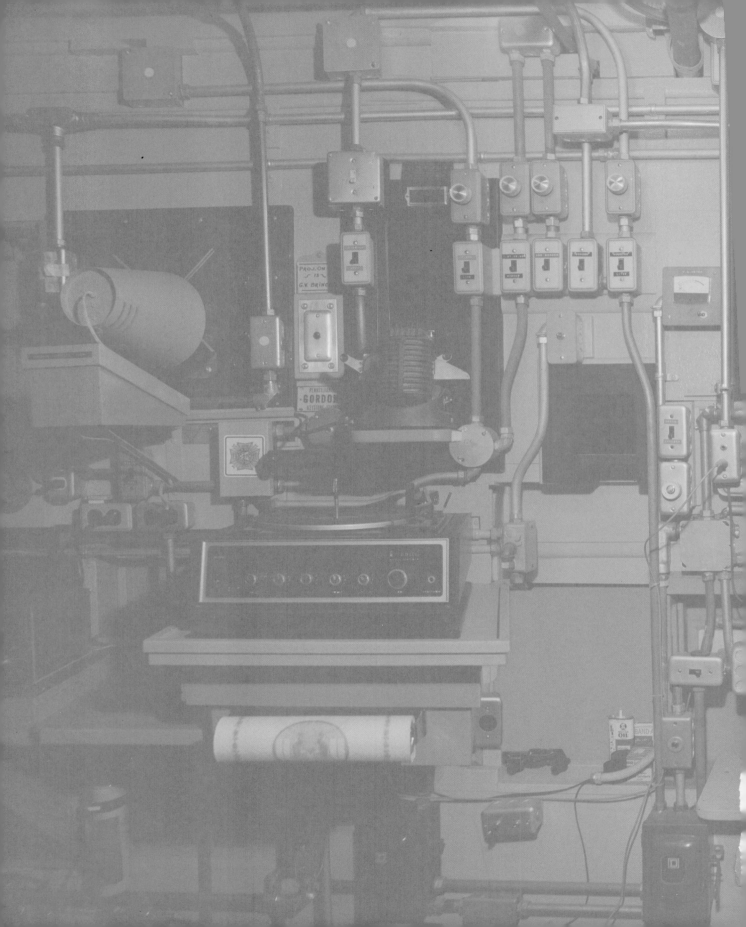